Something to Believe In

Also by Amy Leigh McCorkle

Another Way to Die
No Ordinary Love
Gladiator: The Gladiator Chronicles
Oracle: The Gladiator Chronicles
Set Fire to the Rain
Bounty Hunter
Gunpowder & Lead
Gunpowder & Lead 2
Gemini's War
Gemini's Legacy
When Doves Cry
Scars
Letters to Daniel Vol. 1
Letters to Daniel Vol 2
Letters to Daniel Revised Edition
Bella Morte: Beginnings
Bella Morte: Devil's Backbone
Cornbread
Black Out
Black Ice
Dead Reckoning
Broken: Press Book
Healing Hands

Something to Believe In

Amy Leigh McCorkle

Copyright © 2019 by Amy Leigh McCorkle

All rights reserved. No portion of this book may be copied or transmitted in any form, electronic or otherwise, without express written consent of the publisher or author.

Cover art: by Bob Messinger

Published by. Healing Hands Entertainment

ISBN Number: 9781088744987

Printed in the United States of America

First Edition

Acknowledgements

I dedicated the book to Anabelle, she's an angel and she recommended that I write because she thought that I had something to say on creativity and thriving with mental illness. I'd like to thank my editor and ever effusive cheerleader, Barbara Ehrentreu. She has been supportive in many ways, whether it was to send baked goodies, or send me the traveling pants money she has always been there for me. Next I'd to thank Bob Messinger for creating such beautiful cover art for me. When I received it I was gobsmacked by how gorgeous and dead on that it was. Bob is a friend I made at Indie Gathering. We have yet to work together but we will.

I'd like to say thank you to Del and Theresa Weston. They have showered me with praise and love and watched me flower creatively. AOF rules!

And finally I'd like to thank Stephen Zimmer for doing the formatting of this manuscript for me. Without his help to book wouldn't be headed out there.

And finally to Missy, who without her friendship I may not be here to tell the tale.

Scribble on my friends. Scribble on.

Dedication

To Anabelle Munro who said I had something to say and that I should write this book

Something to Believe In

What can you say about a person who has been held down but refuses to stay down? How do you write about an artist who is so prolific and passionate about the work that to see her grind you understand that you are watching miracles play out right before your eyes? To attempt to capture the essence of Amy L. McCorkle is to begin to reach into the abyss, past depths that you yourself would shy away from.

With all of that being said, here is my attempt to describe the phenomenon of Ms. McCorkle. For the last decade and a half I have seen the creative work of thousands of people from every level of talent that exists. I have read the words of the genius and the fool. Work with nothing more than arrogance and stupidity holding it together and work that I knew upon reading that I would never be able to create. What McCorkle does is in a class all its own and she is continually honing that craft so that her kung fu is best.

This artist has the incredible knack to know that we are all standing on line at the most famous deli in the world and we all have a number. It is a long wait but she knows that like many others who

are too frail, too anxious, too afraid to wait; her turn will come. As she waits however, she is on the move, constantly cleaning up the edges, getting rid of wrong possibilities and searching for the truth and power of her words, her work and what burns in her soul.

In addition, McCorkle, like many other successful artists, understands what dedication, loss, tenacity, passion, talent and fire can add up to be. So, she works independent of failure, which hides just around the corner.

Del Weston

"Start by doing what's necessary, then do what's possible; and suddenly you are doing the impossible." ~ Francis of Assisi

When I met Amy in 2016 at the Action on Film Festival award show night at the glamorous hotel gala room filled with top film makers around the world, I had no idea how our paths would continue and intertwine from then on; Amy and I both would win a major award that night and I remember it, as it was imprinted in my memory like the excerpt of a movie, how I was first happily surprised and then immensely impressed as I watched her give her acceptance speech: Not only did Amy have the courage to stun the room with her bold and courageous statements about being mentally ill, which is itself such a taboo and feared topic, especially if you suffer from it, she moved the room to tears with her heart-wrenching and poetic speech.

Amy gained so much respect from a whole community of seasoned filmmakers, among them

Something to Believe In

academy award winning artists and her bravery would continue to inspire me throughout the following years.

Going for your dreams is surely very much encouraged in this wonderful country build on dreams, hopes and thinking big, but going after the other end of the rainbow so full steam and unafraid while you suffer from mental illness? And making it public! Many artists suffer from mental illness, especially in the entertainment industry but it is well hidden and concealed because of the concerns to be seen as either not being hirable or because of the audience being "turned off" by their "hero's" being actually flawed. So starting out on this journey by making the "weakness" the mighty sword to yield around when smashing all obstacles is incredibly smart as it is daring and truly inspirational.

I can relate to Amy so very much; I myself have suffered from a stigmatized behavioral illness, surely dabbling into the very unhealthy mental health realms because I suffered from an eating disorder when I was a teenager. I myself, just like Amy was bullied at school – I actually experienced both sides, because as a result of being bullied, I decided to find a heavy-set girl with a loud snorting laugh to hide behind and to deflect the negative attention from me onto her. I did not anticipate that this girl and I would actually bond and become real friends where I began to find her beautiful and her snorting laugh the most infectious sound of happiness I had ever heard. But our friendship was rotten at the core and I needed to rediscover my values including my integrity and honesty to be worthy of a friend like her. Breaking this girls heart when I told her a few month later that I had never been her real friend and that I had used her

instead, was one of the biggest lessons in my life. I just couldn't take it anymore – being a liar, cheat and horrible person – from that moment onward, I decided that I would rather be kind and honest and disliked by everyone than that person I was when I based my happiness on someone else's unhappiness.

So my journey as a loner and weirdo continued without the protecting shield of being a bully. Acting, directing and music would become a much better outlet for my inner pain. Just like in Amy's story, my dreams were laughed about – going to Hollywood one day to make it as an actor and filmmaker was being interpreted as having delusions of grandeur. But I persisted. And my faith in God and in myself transformed me on my journey. Healing my eating disorder in the process and the depression and anger issues that came with it was a natural result.

I see a significant part of myself when I look at Amy and I have supported and admired her spirit and creative abundance ever since the day I met her. When I witnessed her getting right back into the swing of making her big project "Letters to Daniel" happen right after that last Action On Film Festival, it dawned on me that observing Amy's creative power could be a phenomenal tool to inspire and motivate other people to step out of the shadows of self-hate: Like a beacon of light, Amy sets an impressive example by counteracting the feelings of being incapable to achieve anything are in itself part of the strong, debilitating grip of any illness but in particular mental and behavioral ones.

When my eating disorder raged within me all these years ago, I could have not imagined in my wildest dreams to be open about it like Amy; it was too embarrassing for me and I felt like such a failure

and liar. Little did I know that one has to embrace the current moment, just like Amy does, including all our aches and sores in order to heal. So Amy's work is much more important than having a crush on a movie star or trying to be famous – it is deep and powerful and encourages people who witness her to continually rise like a Phoenix beyond all the stigma, mocking and doubt of others and herself. Amy is living proof of the power of positive focus, of unshakable faith and tenacity – her work takes away any excuse from anyone to not go for what they dream of.

I love you Amy.

Anabelle Munro

Introduction

Suppose I should introduce myself and explain what this book is really about. I'm Amy and I'm an award winning, bestselling author, blogger, screenwriter and filmmaker. As an author I have 23 published titles to my name and various awards. As a scriptwriter and filmmaker since 2014 I have won 86 awards for my body of work.

There are those who have less. There are those who have more.

I have netted four distribution deals.

There's something else I battle altogether. I'm 43 years old and I have Bipolar Disorder, PTSD and Anxiety. I deal with those illnesses on a daily basis. A lot of artists do. It seems to be the price we pay for what we do.

This idea for this book, was suggested to me by another filmmaker, Anabelle Munro. She's a brilliant actress and a beautiful human being. I'm going to share what it's like to strive to make it in the entertainment industry while also coping with mental illness. Doing one or the other is incredibly difficult. Doing them at the same time is daunting. You have to find a new normal, and for long time, I didn't know if my new normal would include a

career in the arts. But in the end it turned out the arts would be my salvation and would give me something to believe in. So I welcome you to join me as I look back on my journey and share with you my experience in hopes of helping you find your way to defining success on your terms and know what is to be in recovery.

Chapter 1

I can't remember a time when stories didn't fascinate me. Whether it was my dad telling me bedtime stories or watching The Empire Strikes Back from the backseat of my parents' Pinto, something inside me always knew I wanted to be a professional storyteller. Make no mistake. If you are a writer or a musician or a filmmaker you are in the business of storytelling. And if you're like me, it's more than just punching keys on a keyboard or standing on a set yelling action. It's a part of who you are.

My therapist once said is writing what you do or do you eat, drink, sleep it. Missy, my screenwriting partner, producer, and caregiver replied she eats, drinks, sleeps it. Why would my therapist ask me that? Well nineteen years ago my life was in chaos, and internally I was careening out of control. My judgement was suspect, I was paranoid. I couldn't eat. I couldn't sleep, and I was just explosive to deal with. As for my writing, well even that seemed beyond my reach.

With a substantial nudge from Missy and my sister Sara, and indirectly the advocacy work of Emmy winning actor Maurice Benard, I began to seek help.

Amy Leigh McCorkle

In October of 1999 I was sick. When you are diagnosed with bipolar disorder you aren't given a road map how to steer out of the downward spiral you often find yourself trapped in. My diagnosis, for the record, was Bipolar I w/mixed episodes, PTSD and Anxiety. I couldn't eat and I couldn't sleep. Personal hygiene was terrible. And working a customer service job became a nightmarish experience.

Missy and I had moved to Texas to take on Hollywood. That was put on permanent pause. Which begs the question how do you create when your mind is booby trap leading you astray?

The trick is in learning to ride the waves of energy to your creative advantage. There are going to be times when you're more creative that others thanks to bipolar disorder.

In Texas I went through a five month spell where I didn't create anything. The first movie I was able to watch the whole way through was The Insider. In May I would see previews for The Gladiator. It was as if the storyteller in me had been reawakened. I proceeded to write the crappiest, most dreadful muck of a story I'd ever written. But you know what? It didn't matter. Because I wasn't writing with anything in mind except how writing made me feel.

That would be the first bit of advice I would have for anyone with a mental illness striving to make it in the entertainment industry. Create for the love of it. Yes you want to get published/produced and hired to perform, but all that should be secondary. Which leads directly to my next bit of advice, define success on your own terms. Often the first steps of

recovery are taken because people can no longer create.

That's the thing about bipolar disorder, some of its symptoms can be very seductive. The flight of ideas can feel like a high from a drug. If left unchecked grandiosity (thoughts like I can finish this book in one day) and reckless and damaging behavior can follow.

When you're at the bottom, both emotionally and professionally, you should write what you're passionate about. And if you start a book, a poem, a script or film, put one foot in front of the other and the success will be finishing the project.

Where do I start? Recovery sounds out of reach, and finishing a project seems impossible in this state of mind. Admittedly it's not easy in the beginning. You're developing muscles that have been under attack, and they have atrophied because of this.

The first step in moving forward is admitting you need professional help coping with your mental illness. No one can do it alone. Before anything else happens you have to assemble your support network.

The hard part about this is there is stigma and discrimination even now. People can't see our illnesses so it's hard for them to quantify them. That doesn't mean your struggles are any less real or that the pain you endure from them are any less acute.

I know in the beginning it's hard. Just finding one person who will walk the path with you is important. Find someone who will advocate for you when you can't advocate for yourself. In the

beginning, lots of people wanted me to get help. I was out of control, and the way I treated myself and others was brutal.

My first step was seeking help, and if I had not had Missy and my mom helping me navigate the worlds of treatment and disability, I may not even be here today. I chased off a lot of people, but Missy Goodman and my mother Faye Keough, were godsends. My first doctor was Dr. Domrez. Then quickly thereafter it was Dr. Stoller. Even if your therapist and psychiatrist are your only caregivers in the beginning, hang on. If you work with the tools they give you, things will get better.

Something that will help you learn to manage your mental illness is journaling. I did it in the form of a blog, Letters to Daniel. I still blog. You don't have to be as public about it as I was, but keeping a journal helps you look at what triggers you. What makes you productive? What keeps you steady? You will grow in your recovery if you keep a journal. If you use it in conjunction with therapy and meds and other good habits you will find yourself putting together more good days than bad. I'm not saying it's a panacea, but it is a good tool in the toolkit to have at your disposal.

Another key component is medication. I avoided this one for five years. There is a history of alcohol and drug addiction in my family. I was afraid of becoming yet another statistic. In AA and NA (Alcoholics Anonymous and Narcotics Anonymous) there's a very real taboo about taking meds. And I was buying into the stigma that I would become addicted. What I had to learn the hard way, was, psychological pharmacology doesn't work that way. When I was diagnosed the second time I didn't resist the medication. I embraced it.

Something to Believe In

Even though it meant figuring out which drug cocktail worked for me, and it was a long arduous process. My sleep pattern was off kilter. I didn't sleep in my own bed for several years. Missy broke me of the habit when a computer made its way into the house. I would spend hours on Facebook and Twitter. Most of all I would write into the wee hours of the morning.

I still do it now. But another key is when I wake up I get out of the bed and take my medication immediately. If I don't do it then I may forget, and then believe you me I'm not the only one who's going to have a bad day.

Routine is key when talking to someone with bipolar disorder. Get up at the same time. Take your meds at the same time. Go to bed at the same time. If you get your body trained you will start to turn a corner in your creativity and success rate.

The same thing goes for your writing. You've got to train yourself to write anywhere. This may very well be the hardest thing I have ever done. Here's a little cheat sheet. Every November there is a global competition that everyone has the capability to win. You have thirty days to write a 50,000 word novel. I call it fun. Some might call it insanity. From 2003 to 2011 I participated in it. Whether or not you reach 50K is not the point. If you write 1667 words a day for 30 days you will write 50,000 words. Over the course of my eight years participating it gave me a sense of much needed discipline. And in 2011 I received three publication contracts and two of them were for NaNoWriMo novels. (National Novel Writing Month)

I chose to write 1667 words daily. My time at the computer ranges four to eight hours when I'm writing a novel. Of all the forms I choose to create

in long form this is my most therapeutic. You're not on a budget so it doesn't matter where you set your story or where your characters are from. No outrages checks going out. It's only you and your novel. That's the good news of writing. You're in charge with no one to tell you what to do.

It's another way to set up your daily routine.

In the beginning I struggled to create a routine. In October of 1999 Missy and I lived in Texas and it took three separate trips to the psychiatrist to get a proper diagnosis. The first time I was dismissed. The second time I was misdiagnosed. Finally, on the third time I got the proper diagnosis.

Finding the right pdoc and therapist can be like trying to find the drug cocktail. It's a lot of trial and error before hitting upon the right combination. But whatever you do don't give up. Your life and your dreams are far too valuable to give up on.

In the early days of my recovery it was a struggle to do anything. Get out of bed. Take a shower. I couldn't and still can't hold down a "regular job". Just getting out of bed had to suffice for a major accomplishment.

As for making it in the entertainment industry, I became an avid Maurice Benard fan. He was one of the few actors at that time being open about their struggles with bipolar disorder. He stars as Sonny Corinthos on General Hospital, and off screen he was an advocate of for those of us with mental illness. I gravitated towards him as someone to look up to and to emulate. I wanted to advocate through my work but I would first have to get better.

Something to Believe In

Create for the love it.

Define success on your own terms.

Get professional help.

 1. Take your meds

 2. Start a journal.

 3. Find the right pdoc and therapist

 4. Establish a routine

Chapter 2

I should say this, good things don't just come to people. I had to learn what worked for me and put together that list. I find when I follow it life goes better for me. But it's not perfect you can still find yourself in the midst of a bad day even when following the list. Bipolar disorder is not known for playing fair.

I find sleep to be the most difficult thing to manage. I often think, there's so much to do why do I have to sleep. But when I get a good night's sleep I get more done the next day.

In the first year of recovery all I did was write intense letters to my favorite actors. Nothing off your rockerish, just simple fandom of how I appreciated their work. In my early twenties it was "Highland" the television series and "the X-Files". Both were moody and atmospheric with romantic notions, and conspiracy theories. It was good television and pure escapism for me.

That's when the itch to write for Hollywood struck. I was already writing with dreams of publishing in my head. It seemed a natural progression to want to write for the movies. A part of me was always day dreaming movies anyway.

But before I could move on the screenwriting, Missy approached me to write a romance series. I, being the snob that I am, said sure, let's do it for the money. What do you get when you put two pantsters together who try to outline? A never-ending sprawl of an outline.

We lived on RC Cola and Twizzler Pull n' Peels.

That was twenty-one years ago. We no longer have the outline but Missy is revisiting the story. I can't rediscover what has already been written. She can fashion it into something new.

Twenty years ago pre-diagnosis we would write twenty-pages at a time. Albeit it was crap but I was a slave driver demanding Missy function the way I did. She tried to keep up. But trying to keep up with a manic individual spiraling for a breakdown is a losing battle.

Caregivers are hard to come by. The hours are long and the task, especially early on, is thankless. I didn't have the language or ability to see out of the dark pit of despair I was in. And with no stories to tell I was especially unbearable. Yet Missy Goodman did not run. She did not hide. She did not always know in the beginning how to de-escalate volatile situations. However, she was always there for me, and during the crisis point she encouraged me to seek professional help. Well, demanded it.

In the beginning it can be hard because you feel like you are lost and alone. You want what once seemed to be possible. Your world as you knew it has been ripped away. I lost my creative voice. I started projects and did not finish any of them. I had to learn to write on my own all over again. Even though I dreamed of New York and LA, I secretly feared I would never get to either place.

Mixed Mania is hellish. Even though my dreams

seemed to be slipping through my fingers, I fought to hold to them. I owe a special debt of gratitude to Maurice Benard. His willingness to advocate and to share his story openly, allowed me a better understanding of my mental illness. More than that, it let me know I wasn't alone. And that there was someone with my disease who was pursuing his dream as actor and living in recovery day by day.

He imparted that meds did not kill your creativity and that if the meds were making you feel like a zombie then it's not the right combination of meds. It's about baby steps and finding your "new normal".

Getting the proper amount of sleep is tricky. Those racing thoughts can keep you awake. Lights. Noises. I often blog shortly before bedtime to get the negative out. I don't always think clearly. If I'm hurting or angry the blog acts as a safety valve. And it's a way of tiring my mind out.

Always have a project going. Say you can't handle a writing project. Try another outlet. Painting. Knitting. Sculpting. So what if you're not as good at it as you are writing, this is something that should bring you pleasure just in the doing of it. Writing or whatever your main artistic endeavor is should be fun. The minute it stops being fun ask your caregiver what your mood has been like. Often they are better barometers than you are of how you are coping with life in general.

Journaling will help you in learning your own rhythms and cycles when it comes to your moods. You'll begin to see the subtle warning signs that you're falling into depression and racing into mania.

As soon as you begin to see the patterns you can start putting together a plan of action. Are you depressed? Do you feel as if you might harm

yourself? Find a friend or a family member to contract with for safety. Where they agree to be there for you no matter what, and you agree not to harm yourself.

It should be someone you trust. Make it someone who loves you and isn't going to make you feel bad, because you reached out to them.

The first story I wrote while in recovery was more like Gladiator. It was really bad, but I wasn't trying to impress anybody, I was writing because it felt good. And in that first year there wasn't a lot to make me feel good.

While in Texas we had planned on making a movie. We had a script. We auditioned close to 500 people. But that was where it ended in Texas. No movie. I had a second emotional breakdown when I was fired for being open about my mental illness at the glorified daycare where Missy and I worked.

Still the dream persisted. While watching an award show, Maurice Benard won for Favorite Lead Actor. And in his acceptance speech he thanked his wife, the fans and said, "To anyone out there who has bipolar disorder, if I can do it so can you."

In that moment I felt I had been thrown a lifeline. I grabbed onto it and held on for all I was worth. I couldn't imagine a life where I would be going to comic-cons, literary conventions and full on film festivals, but Maurice was saying this as advocate: Bipolar disorder is not a death sentence. Life is not over because you have to take medication and see a therapist. It's a chance to begin anew and reclaim your dream.

I know it sounds corny but my dreams are at the heart of why I'm still alive. Even when I was writing complete shit, I was dreaming. I was undeterred. I was getting better. To make it in such a cutthroat

Something to Believe In

industry you have to find your tribe. And my tribe is the mentally ill who dare to grab life by the throat and refuse to let go.

Sure, we've all been burned by some idiot. In 2000 I found myself at a crossroads, move back to Kentucky where I could get help or stay in Texas and sink. Rest assured, at the time I was 25 years old and was sure that moving back to Kentucky was the worst thing that could befall us.

I made life for everyone around me, including and especially, my closest ally in this fight, Missy, a living hell. To be in my head was agony at that point and though moving back was the smartest thing we could do, I resented it. I felt like a failure. As if my dreams were out of reach. I was in pit of mixed mania despair, and even though the rope had been thrown down, I was too weak to crawl out. All I did was pull my caregiver down in the pit with me.

Missy soon ceased to write with me. I used to resent her for it. What I see now, that I was blinded by illness to then, was that Missy was so busy working three jobs and in her free time taking care me, she had nothing left in the tank to give creatively.

Yet in 2003 she told me about NaNoWriMo. And I proceeded to write out in longhand, my first 50,000 word novel. She cheered me on. She drove me to Borders and gave me coffee and bagel money. And when I crossed that finish line she took me out to celebrate.

Missy would write but she didn't want to sit down together and write together yet. That would take a while yet. I can be a demanding person to work with. We were always living hand to mouth. The threat of having no money was a constant reality.

But once we were in Kentucky I was writing novels. The next step would be looking for a publisher. In the meantime we made sure we went to the movies and to the bookstore. We even saw "Wicked" the musical.

During what I call the lost years, I was doing monster work in the therapist's office. Constantly pulling back layer after painful layer so that I might be well enough once again to rejoin the workforce.

I don't know if I'll ever rejoin the 9-5 punch a clock workforce. Being a creative often soothes my nerves and makes me a happier person. Yes, I still have my bad days. If it rains for days on end with no sunshine it really does a number on me. Sunlight is a gift to me. I can't say I am always in a good mood if it's sunny and blue skies but it makes me less likely to isolate and trigger the depressive side of my disease. As long as I have a creative project to focus on I'm able to get out of the bed in the morning. And sometimes that's just how it has to be.

Chapter 3

It's always the hardest right before you break through to any kind of success. It feels like you've been pushing for so long, and your head seems to keep on hitting the ceiling.

As a novelist I began pushing for publication at thirteen. I received a lot of rejection letters over the years. They ranged from the form rejection everyone gets to the "your writing is great but we can't find a home for this" line. It would be until I was thirty-five for me to land my first publication contract with MuseItUp Publishing, a small press out of Canada. My time with them would be well spent. I benefitted from their editorial staff and my writing voice remained untouched.

There have been near misses with agents and close calls with Hollywood. All of my success has come from creating independently. There's a world of difference between writing for hire and writing for yourself. Writing for hire is where the money is at. Writing for yourself is your calling card to get there.

Writing for hire is probably the hardest thing for me to do. But in Hollywood that's what you do. You're servicing the director's vision; unless

of course you are directing your own script. This is why I'm still an independent. I want to direct Letters to Daniel. There have been nibbles before by Hollywood but ultimately no takers so far.

Writing is more than just something I do. It's one of my defining characteristics and what makes Amy, well, Amy. There are other things that do that, including my intense personality, but my ability to feel joy with no filter and pain without end is in there to. I am empathetic and I always encourage the person coming up behind me to dream and to put action behind those dreams.

When it rains for multiple days in a row I struggle to do anything. My disease rears its head on those days and writing and working on my films and scripts becomes an uphill battle. But I try to do something every day.

On the bad days I try to be gentle with myself. I'm doubly sure to take my meds. I'm extra careful to force myself out of the house for at least a little while. I'm careful to get enough sleep, and I sit down in front of my writing projects and pick one to get some writing done on.

My first legitimate contract was, like I said, with MuseItUp. And after twenty years of trying for publication I felt validated. I danced. I cried. I hugged Missy. Another Way to Die was the first book I wrote casting Daniel Craig as the hero.

It was the year 2011, two more contracts would follow: one in April and the other in December. When writing those books I felt complete and utter joy. They poured out of me like hot lava out of a volcano. In 2012, my first print book, Bounty Hunter would be contracted. There's even an audio version of that book. I achieved bestseller status for the second time with that book.

Something to Believe In

As for Hollywood I hadn't attempted a screenplay in five years. But while touring with the book, Missy and I started adapting Bounty Hunter to script form. In 2013 I would complete it.

I managed all this by keeping a routine of writing four to eight hours a day, taking my meds and keeping my doctor's and therapy appointments. And finally, writing the "Letters to Daniel" blog. But 1999-2011 were my lost years.

I damaged relationships, faced stigma and discrimination in the workplace, and struggled to keep my head above water.

My time at Children's World was during my first year of recovery. They called themselves a pre-school but they were little more than a glorified day care with the worst kinds of people working there. They were all led by their Nazi like leader Myra Hutton and her assistant Natalie.

During my time there they turned a blind eye to the possible molestation of a child, mistreated a child with severe anxiety, and ultimately discriminated against me for having a mental illness.

They saw me as liability. Who knows where they are now, but their actions led to my second breakdown inside that first year of recovery.

It was right before I was due to make a trip to New York to go to Maurice Benard's personal appearance in New York at the Brokerage Entertainment Center. Missy and I had written a script, "You're the Reason". Looking back I was highly unstable. A mixed mania was triggered by Children's World firing me. This triggered a downward spiral that led to me being awake for 72 hours straight while preparing the script.

I boarded the plane in San Antonio with Missy early in the morning and proceeded to fly to the

airport in Newark, NJ. Once we arrived we met up with a friend and got in the rental car to head to the hotel. It was there the bottom fell out.

I fell asleep and left Missy to deal with a know – it - all friend who would ask her to read the map and then proceed to ignore her. I slept the whole way to the hotel.

The next night was Maurice's appearance and the goal was to get him the script. The comedy club was tiny, dark and packed to capacity. Missy took the brunt of my mood as I told her, shut the fuck up you're ruining my good vibe. I think the only thing that saved me from a punch in the face was that the girl sitting next her was more unstable than I was.

A comedian warmed up the crowd, and then it was time for the main event. Maurice was announced. In pitch black darkness the crowd erupted in noise, applause and flash photography. These were cameras. In the year 2000 cellphones weren't as ubiquitous as they are now. And none of them had cameras on them. In all that chaos I was pushed past my breaking point. I covered my ears and squeezed my eyes shut. It was a sensory overload and my bipolar disorder was ready snap. Instead it drove inward. And when he finally called on me it was all I could do to hand him the script. I had no words. I was physically, psychologically, and emotional in a no man's land of misery.

The rest of the trip to New York was a bust. We didn't get to go sightseeing, and all we experienced in New York were rude, condescending activists, and soft-hearted transgendered prostitutes. But that story is for another book. (Really? I'm intrigued. Put part of it here I think)

We raced through the airport just barely

making our flight on time. We were in an all out sprint. It would never happen in a 9/11 world. We would have been forced to miss our plane and pay for another ticket.

 That trip was made possible by a generous friend, Anothny Casebeer. I don't hear from him these days. Which is sad, because he featured prominently in my life for a very long time. While we were in San Antonio he made a trip to work on Missy's car and set up a computer. And he set us up with a six month supply of groceries.

 The only drawback was fundamental understanding of where the boundaries of our friendship lay. He always romanticized our relationship, and his friends saw me as a threat when he did finally meet who I'm sure is a lovely woman. I went to his wedding, but our friendship faded afterwards.

 I don't know what he told her about me but I can't worry about that. After that trip it was a steady spiral to the bottom of the ocean, and I was writing nothing once again.

<p align="center">***</p>

The move back to Kentucky was not a welcome one to me. For Missy it was cause for celebration. For her it was a reunion of sorts. For me it stood in sharp relief of all my hopes and dreams, which at the time seemed ever further away than when we moved out there.

 The computer was placed in my room on the dresser. I spent sleepless hours starting stories and surfing the AOL fan boards. (I know. I'm dating myself) But in those months it was rocky going. I unfairly blamed Missy for our return home. I actually

had precipitated it. I could no longer hold a job or lead a normal life. Everything revolved around the illness, and that included intense bipolar rages I'm sure everyone in our apartment complex were privy too.

At my sickest I threatened Missy's life. How she coped I have no idea. I've asked her over the years what made her stay when things were so tumultuous. She said Goodmans don't run. Plus she may have been somewhat co-dependent.

She is quick to tell me I am not a monster, that I have worked very hard on my recovery, and that I am a good friend. I just have to keep an eye on my moods. I can't express how fortunate and lucky I am to have someone like Missy in my corner. Navigating the unpredictable waters of mental illness and Hollywood requires you to keep your priorities in order and having your caregivers there is essential.

Chapter 4

Caregivers are everywhere you look. They are doctors and therapists, mothers and fathers, sisters and brothers. Even trusted friends can be caregivers. Caregivers are the people who do the often thankless work of loving and caring for you when you can't care for or love yourself.

Anyone can be a caregiver. Even a close friend can become a warrior for you. Being a caregiver for someone who has serious mental illness is not easy but it isn't something that should be shunned. If you are close to someone with mental illness it is important not to stigmatize them further.

Caregivers are often the people who become collateral damage when you experience euphoric mania, go on spending sprees, drug and alcohol binges, or are left with a broken heart when or if you become hypersexual. They are the ones who do battle by your side when all hope seems lost, and they're the first ones to celebrate your success when it comes.

As you strive to elevate your creative career you must have caregivers in place. Some people have the disadvantage of being separated from the very people they count on to help them maintain

stability. One filmmaker told me the pre-production process nearly broke him. I understand. The same thing happened to me when "Letters to Daniel" was nine days out from production and the other producers pulled out.

It devastated me and sent me into a downward spiral, which led to two experiences with unscrupulous managers and agents. It left me lacking in judgement and bought me whole lot of heartache.

Then I decided I would go naked (sans agent) until the situation presented itself where I was ready to manager up. A year post fallout things are going well. But I'm not where I want to be yet. (You might want to say Two years post fallout)

It was my caregivers who supported me during my recovery and sustained me when I thought I wasn't going to be able to get back up on my feet again. They kept the dream of "Letters to Daniel" alive when I felt like a part of me had just died. At that time I thought I'll never get "Letters to Daniel" made. To be so close to getting it made, only to have it ripped away stands as one of my most gut wrenching professional project setbacks.

But here I am now thanks to the hard work I put into my recovery with my pdoc and my therapist along with the support from Missy and my parents. And my creative heart was put back together by my film family. Most specifically Del and Theresa Weston and the Action On Film International Festival. Aka AOF Megafest.

They were the caregivers of the soul. They gave me the confidence to blossom and take back control of my directorial dreams. They are beautiful people who showered me and Missy with love and creative support. And they do it every year like clockwork.

Something to Believe In

Del and Theresa are special to me. To say I love them is the understatement of the year. They earn the label of professional dream caregivers.

Hollywood is a mercurial place. Much like bipolar disorder, its highs are incredible high and its lows are incredibly low. A career in the arts is such a crapshoot. That's why you have to ground yourself in reality and love the process of writing for writing's sake. The writing is my therapy. When life is wobbly and I'm not writing it speaks to my well being, or rather, my lack of well being.

When you are successful at a certain level, you're stable and you want to enter the fray of professional screenwriting and filmmaking, make sure you have your caregivers in place. Hollywood tends to eat its young, and if you even if you are stable, it can chew you up and spit you out. So you have to find the joy in the process and every success now matter how big or how small should be celebrated.

Just like with your recovery. Every step you make in recovery should be celebrated. Much like your career, recovery is a long arduous journey, filled with highs, lows, stability, and many adventures in between those times. And having someone or multiple someone's alongside you makes the journey better and easier to endure than if you attempt to take it alone.

Caregivers also take care of you and monitor your behavior when you might be breaking off into a spiral that will lead you into an episode. I'm pretty good at monitoring my moods but sometimes I'm too close to it. For instance, I wanted to sleep all day. And for the most part I did. I couldn't stay awake. Some of it was my meds. Some of it was due to my blood sugar being so elevated.

Amy Leigh McCorkle

Mom is my self-appointed caregiver when it comes to my Diabetes. Rather unsuccessfully. I find my mental illness easier to accept than my diabetes. Both of these illnesses plague my family. I wish I could get rid of diabetes with a magic pill. But with my mood disorder it's hard to see where I begin and it ends sometimes. Is it the price I pay for being creative? I wouldn't take a magic pill. I'm decidedly ambivalent about it.

Some days I would and sometimes I wouldn't. Today I wouldn't. Even though the last few days have been troubling. The sun was out today and I felt absolutely hateful. I didn't want to be around anyone or anybody.

Yet my aunt was here, a chronic whiner and complainer. She's also bossy as hell. Plus my nephew who was home from school because he was sick was here as well.

I was his caregiver. He had strep throat. How unpleasant for him. I did a crappy job of seeing to it that he ate and had his medicine. The sleepies came upon me, I'm sure there's a bit of depression in there for good measure. (What happened? Was he okay?) October to until about February proves to be a hard time for me. So those ever-present caregivers are there to catch the brunt of it.

The entertainment industry has taught me a lot about my craft, how to hustle, how to always try and put my best foot forward. Caregivers do those things too. Only they're doing them to care for you and make sure you are stable.

I wish I could say I'm always grateful and I am loving towards my caregivers. But in truth I am hard to handle. When I am experiencing mixed mania there is a lot of irritability and anger, which boils over at the slightest provocation. Hell, there

doesn't even have to be a provocation.

Bipolar disorder is to life what the paparazzi is to the entertainment industry. It takes much more than it gives. They are disruptive, damaging and there's nothing they like more than to tear someone down to their knees.

The perfect example is the star who yields under the extreme scrutiny of such things. The stigma of saying mental illness in Hollywood is so bad they checked into rehab for "exhaustion".

Their caregivers are nowhere to be found. They are surrounded by "yes" men and women who see fame as their only real attribute.

Take Kanye West and the whole Kardashian set-up. She's busy preening on television meanwhile he's stopped taking his meds and is coming undone for all the world to see.

To be fair, mental illness can grind down the best of us. When you're on the front lines of it day in and day out it can force you to cry uncle.

Just like the white hot spotlight of fame, it must be managed or it will knock your knees out from underneath you.

I often thank God for a second act. Even though I have cursed him many times over for having this disease. I'm experiencing success in recovery. Had I achieved any kind of success early on, I wouldn't have been able to sustain it. For most of my twenties and part of my thirties I was busy playing in the sandbox with my creative tools. I was trying desperately to heal and to make my dreams a reality.

To be honest at times it felt like I would swimming upstream for the rest of my life. Sometimes it still does. But thanks in no small part to my amazing caregivers I have a new normal for myself, and life

seems full of endless possibilities. My dreams seem to be coming true.

Chapter 5

The hardest part about learning to cope with mental illness is learning how to ride the waves. It's accepting that you're going to have your productive times, and you're going to have times when you're going to be lucky to get out of bed.

As you progress in your treatment and recovery, and you journal your experiences, you are going to begin to notice when those times are; and you're going to be able to capitalize upon them.

This isn't going to happen overnight. It's like learning to paddleboard before you surf. It's going to take some time to learn how to paddle out and stand upright on the board. Your mental illness will test your balance while the sharks in the industry will be after your stability as well in terms of your career.

I had to learn to make time for my writing because no one was going to give me time to write. People say I don't have the time for themselves all the time. They say you have the luxury of all the time in the world. I have the same twenty-four hours in a day that everybody else has.

Establishing a routine for myself was key. It's a fundamental key to success -- the, paddling

out into the ocean if you will. If you set a time for yourself to work everyday it will become like second nature. It will be easier to do some days than others, depending on your mood's "current". However, the more often you do it the more you'll see your skillset improve. And you can advance to shopping your projects around to manager's and agents. You will be "standing upright on the board", and eventually, you'll be "riding the waves" or consistently creating according to your own cycles.

It took me a long time to create a foundation. When you are sick you are often at the mercy of your illness. When you are in its vise-like grip creating seems like some far off ephemeral dream.

But as my treatment progressed the creative itch returned. And once I had a strong foundation from which to work it was a matter of putting in the effort to succeed the way I wanted to. I dreamed of bestseller lists and awards in publishing. I dreamed of Oscars and Golden Globes in filmmaking.

To date I have 23 titles published, 11 of them are Amazon Bestsellers, I've also won 10 awards for my books. Including Bounty Hunter, Gemini's War, Bella Morte, and Letters to Daniel.

I haven't won an Academy Award but Missy and I have been fortunate on the film festival circuit. Since 2014 our scripts, music videos, documentaries and short films have netted us eighty-six awards and forty plus more nominations. I'm not saying these things to brag, but to demonstrate that being productive and successful in recovery, on medication is very possible.

I've discovered my natural creative rhythm runs late summer/early fall to late spring/early summer. And that film production fits in late fall/early winter. So I strike hard and often in those

months. The summer months are reserved for film festivals (if accepted into them) and networking. Those are my waves.

Bipolar disorder, is by its very nature unpredictable. It can throw a monkey wrench into all of that. It is then you respect what you're going through and employ your self-care methods.

When I'm depressed I'll allow myself the right to burrow in my bed and sleep, to lounge around in my pajamas and watch television. I make my goals simple. Get out of bed. Get out of my pajamas and into jeans and t-shirt. Make sure I take my blood sugar. Make sure I eat three meals. And on a really hard day if I make it into the shower then I reward myself.

Those waves, when you are riding them, can be exhilarating when you are creating. It brings joy and sunshine into what can be an arduous journey. So often we are walking in the dark, feeling isolated and alone. Use your creativity as a way of breaking free of that slippery slope.

Learning to master the waves is an ever-evolving process. Sometimes I am better at it than others. When I am riding it and I am creating, all the hurt, all the pain, all the misery has been worth it.

Healing takes time. It's not an overnight process, and, before you can get to enjoy the waves, you have to heal. I was initially diagnosed in October of 1999. My first publication contract did not come until 2011. My first screenplay win was in 2013. And my first film award was in 2014.

You can't rush getting well. Everyone gets better on their own time frame. I went through countless social workers and doctors over that time frame before landing at Seven Counties of Louisville, which

is now Centerstone. When you are indigent you are at the mercy of whatever programs they have for you. If you're lucky enough you have insurance that covers you and your meds. I'm currently on disability.

I don't want to be on disability. I have hopes that my creative career will transcend the independent level or that my books will rake in the money while I pursue a creative career as a director and an advocate.

I have one memoir published, a finished manuscript in "The Guardian" which addresses stigma in the church, and this quasi how-to-do what I'm doing/while coping with severe mental illness non-fiction book. My films also deal with mental illness and substance abuse issues. More by accident than design I have created myself a platform from which to speak.

This has all come from riding the waves and is incredibly exciting to me. In October of 1999 when I wasn't sleeping, creating or eating much I could have never imagined this for myself. No, I'm not insanely wealthy or famous, but I am successful.

I have my sanity, my health and I create on daily basis. I have a roof over my head, clothes on my back and food in my belly. I have friends, family, caregivers and colleagues. I have a rich and rewarding life.

My main caregiver was a best friend who turned into an ally and a sister. The only thing missing from my life is a romantic relationship. I would be happy to have one but it would require work. A lot of risk for a reward with the chance of failure.

I often wonder what having a romantic partner would actually add to my life. A romantic partner automatically is signed up for caregiver status

whether they want to be or not. Plus there are terrible symptoms I haven't had since the 2000's. Anger is one thing. Bipolar rage is quite another.

I've felt it in all its power and glory. No one understands what it is like to be around it until they've been on the receiving end of it. When I feel the irritability reaching its long fingers around me, I try to remove myself from whatever it is that is triggering me. And romantic relationships, as wonderful as they are, require work anyway. It's especially true when one or both partners have bipolar disorder.

Under the white hot light of the entertainment industry having a partner you can depend on to be a touchstone is important. I may not be romantically involved with anyone, but my writing and producing partner and sister in crime is right there with me. And while I'm hardly under a white hot light, the stresses of pre-production on a film can test the mightiest of people. For people like me that is especially so.

When working on a film it is key you have a team that makes things easier on you, not harder. There should be at least one person who isn't a yes person. Someone who will always be honest (not cruel) with you and offer you a soft place to fall when things get too hard for you psychologically and emotionally.

My team is made up of some awesome people. I have mentors and have learned a lot thanks to them. Del has taught me to make it happen. Clint Gaige has made me a better editor and director thanks to his advice. Mark Maness is a helluva of a DP and has counseled me as well.

The most amazing thing about having these mentors is that they're all just a click away on

Amy Leigh Mc Corkle

Facebook and email. Some are even a phone call away. Clint and Mark are a part of my "Letters to Daniel"team. June 2019 can't come fast enough. Those mentors can help you ride the waves, get the most of your craft and help you see yourself in your best light.

Chapter 6

Being mentored and mentoring those you can help is not only a great way to network and get ahead it's like advocating for people who are further behind in their climb up the industry ladder.

In my twenties it was a bit like swimming upstream. Missy and I took two professional level workshops. The Hollywood Film Institute's 2-Day Film School and HFI's Film School for Writers. My instructors were Dov S Simens and Michael Hauge respectively.

Excellent teachers, they gave me a rudimentary understanding of how things worked and how things wouldn't work. In the close to twenty years since I took these classes things they've said have pretty much born out to be true.

Dov famously said running a camera is like driving a car, some are just better drivers than others. Ray Szuch added, and some learn over time to be better drivers. (Are these direct quotes?)

I'm learning. Ever learning to be a better writer and a better director. I learn from my actors and my crew each time I step onto a new set.

I want to give my actors what they need in order for them to feel brave enough to be vulnerable and

trust me to give their best performances. I want to be open to what the crew says, because I'm still learning from the technical side.

The way I give back is I encourage those around me to pick up a pen and write their first substantial story. Whether it be a novel or script or a short story. They often get bitten by the writing bug.

I feel especially proud of my mentorship of my cousin Rebekah. Our lives are parallel, one another in many ways. We are both writers, but with twenty years between us, Rebekah often benefits from my hard won lessons in life.

At eighteen she came to me to share with her what I knew about writing. I said you need a blog, a website, Facebook and Twitter. These days there's Instagram, Snapchat and countless others to choose from, but when you're first getting into the game of publishing and writing you should at least have the basic four.

That's for purpose of marketing. I can already hear the collective groans. Who wants to market when you could be writing? But that's the reality of today's publishing landscape. You have to promote yourself. It's an unpleasant and uncomfortable fact of life. That doesn't mean tweet repeatedly, "Buy My Book", or "distribute my film". It could be you describing what it was like to write that book. Or how much you enjoyed working with everyone on your latest film.

Helping Rebekah through the early stages of her career was a blessing not just for her but for me. It was my first taste of one on one advocacy. She was having a hard time in college emotionally, and when she described her symptoms all my instincts screamed "bipolar disorder".

As she wrote her first novel, Gears of Golgotha,

she flew through the task like a bird taking flight. And when she lost 10K of her novel she wrote 8k+ words in one night so that she would have the book in time for Imaginarium.

She wrote her first two scripts, and won Best New Writer at AOF, an award that me and Missy had won the previous year.

Rebekah has written Alpha, which is in edits. And a television pilot script, "Golgotha", based on her novel.

We have attended AOF together for the past two years and have enjoyed every last minute of it.

The beautiful thing about Indie Gathering and AOF is that they are incubators for up and coming talent. Every year at these places it gets better and better.

In 2017 I encouraged four others to enter AOF's writing competition. All of them were writing their first screenplays ever. I counseled them but they did all of the hard work. All of them were nominated, two won and 1 came in 1st Runner Up. Since I won that night too everyone was on cloud nine.

Watching my friends and cousin soar was better than winning myself. Good karma is a reason to do something. But doing it because it is the right thing to do is even better. It is my firm belief that there is room enough for everyone.

But I am careful to impart that while winning is nice, production is the name of the game. When my friends and cousin start making films off of their scripts then I will be bonkers with joy. Because not only will my voice be heard so will theirs with all their stories ready to take Hollywood by storm.

Amy Leigh McCorkle

My mentors are amazing. Some inspire me even though they don't have a clue who I am or what I'm doing. What I like and try to emulate about my mentors is that they seem to always be present for their fellow artists. They may feel overwhelmed but somehow they teach others while producing amazing work themselves.

Thanks to Del and Theresa Weston my films are steadily getting better. They put on amazing seminars, and just being at their festival has allowed me to meet other filmmakers who do amazing things and are willing to share tips and tricks on how to do things better.

I strive to get better each time out and I get feedback that lends itself to constructive lessons I can then employ to make the film better.

It's like listening to your psychiatrist when she tells you to take your meds. Or the therapist when you get to the root of what is really triggering you.

Caregivers and mentors are some of the keys to anyone's success. But the fact remains you are in control of your own destiny, whether it be as a writer or filmmaker or any other facet of the film industry.

Mentors can give you a road map but they can't do it for you. They can help. They can counsel. They can shower you with love and lift you up when you stumble. They can caution you against those who would use you. They cheer you on when the journey is hardest.

I thank God for my mentors, because some of them have become the caregivers of my dreams. They champion my work. They respect me as an artist. Trust me, this goes a long way. In return for

all that they do I champion them and their festivals. I adore their work. And I shower them with love.

I never thought at forty-three years of age I would ever get a shot at bringing my dream project to a bigger stage. It has been a journey of almost six years. Some passion projects never get made. The most beautiful thing is that everyone has been pushing this project forward.

"Letters to Daniel" isn't just a book and a movie, it's a look at my life with bipolar disorder without the rose colored glasses. Raw, gritty and inspirational I seek to help other people with this movie. To let them know they're not alone. And that if they put in the work towards recovery, that they can do more than hang on by their fingernails. They can survive and thrive. That's the message I want to carry forth in my work.

My mentors taught me, just because you are different doesn't mean you're any less deserving of amazing things. If you want them you only need go after them.

By that I mean do the work. Do the insanely, monumentally hard work that goes into creating anything of worth. Find your joy and purpose in the process, because that what will sustain you over the long haul.

My mentors saw me floundering, scooped me up and whispered in my ear, you can do this. When no one else was. My caregivers were putting a roof over my head and feeding me so I could pursue the arts as a full time thing.

Embrace your inner mentor and start sharing what you know. It is incredibly important you keep healthy self-care in mind. And above all always keep moving forward. Mentors and caregivers do a lot, but you must carry your dreams, because in

the end you know your dream the best. I have been lucky. My writing partner and producer has become my most important ally in that she rode the major storm and has learned to ride the waves when they come. She may not always be happy about it but she doesn't regret it.

Chapter 7

I've always been enamored of stories. Books were my first love. Writing was my second and television and movies after that. I knew I wanted to be a writer at five years of age. Even though me and my cousins and sisters would present "dinner theaters" for our parents, I wouldn't be able to articulate I wanted to write for the movies until I saw the movie "Dead Again". Scripted by the great Scott Frank ("Godless"), and directed by Kenneth Branaugh, it's a supernatural love story wrapped in a whodunit.

I loved that movie. I loved the way it made me feel. And I thought surely I can be a part of that too. But every university that had a film school cost more money than I could get my hands on. It would have required a Parent-Student Loan. My parents wouldn't do it. I resented them for it. If I'm honest, I still do. But on the other hand, my illness first manifested in late high school and early college. It ambushed me and put a bullet in my collegiate career.

Turned out, it was a good thing that they didn't do it. I would be in more debt than I already am.

The other movie that I fell in love with was

"Last of the Mohicans", the Michael Mann directed version. I was swept away into the historical world of pre-Revolutionary America. It made me fall in love with the epic romance between the leads and the quiet love story between the secondary characters.

I knew then I wanted to be involved with the movies. I really didn't care how. I didn't have the first clue as to where to start. So I bought How to Write A Movie In 21 Days by Vicki King and was off to the races. Well sort of. I was seventeen when I attempted my first screenplay. How did that go? I completed it. And it was complete and utter crap. Sure there's glimpses of my future work. It was a success in the sense I finished it. But its only real purpose is to show me just how far I've come.

Then I switched to novels. By definition they weren't really novels. They were novellas. They weren't long enough to be novels. I got a lot of rejection letters in my twenties, from publishers, from festivals. No one wanted my stuff. Fortunately that didn't deter me. I had a desire to keep writing. I loved my stories. Looking back they were deeply flawed but when Missy and I started writing together I like to think we picked up each other's good habits. Like I learned about dialogue from her and she learned about action from me.

We stumbled across an ad that read, film school for writers. It was a two day workshop in Lima, Ohio. I brought my boom box (yes I know I'm dating myself again) along the way we jammed to Weird Al, Lauryn Hill, Salt n Peppa and listened to the score from "Titanic" for the six hours from Louisville to Lima.

It was March of 1998 and it was Final Four weekend in college basketball. The weekend would totally change the trajectory we were on. Instead

Something to Believe In

of writing the endless outlines we would spend a solid decade writing scripts. There were flashes of greatness but only to watch them quickly fade into the distance. Our first project stands as our most enduring. "When Doves Cry".

When we went to write the screenplay we needed to agree upon an actress with the chops to play twins who are heir to a criminal empire. We couldn't think of anyone, and then we went to see Titanic and fell in creative heaven with Kate Winslet.

I would like her so much that I would take her first name as part of my pen name. I went on to cast her in my books as the heroine. Her acting was sublime at every turn. And she seemed to give me countless opportunities to tell different characters different stories.

In 2014 I would make my first documentary. With the help of Missy and another one of our friends, Pam Turner I would create "Letters to Daniel: Breakdown to Bestseller". It was very rudimentary. A series of photographs set to me reading twelve of the original letters from my blog, "Letters to Daniel" that gave the greatest impact.

It told the story of what it was like to live daily with bipolar disorder. It only had one song at the end, provided by Danny Jones. "The Wind Blows Through My Garden", A beautiful song that he has remastered with an orchestra and back-up singers for the upcoming narrative feature "Letters to Daniel".

That first documentary went on to win several awards and screen at Imaginarium. On my proudest night it screened at Action On Film on a beautiful movie theater screen. For the first time, I felt like a real filmmaker. Like my work mattered, like I

mattered. And I was ready to go home and make more movies.

Next up was my first short narrative, "Broken", which Missy produced, I directed and we wrote. It was a tale of an amputee veteran dealing with drug and alcohol addiction and feelings for a woman other than his wife.

I learned how to run a set, have food and drink available and provide a bunkhouse for the cast and crew. It was the most beautiful on set experience I've ever had. The cast, Brandon X Bell, Taura Schmitz and Maria Christian were all amazing. My crew, Sterling Hall and Delilah Stephans were great too. We moved as one unit and it was a happy set.

I've since worked with Brandon on another short film, "The Weekend". And Maria has become my first choice as a narrator on my documentaries, "Black Gold: The Trail to Standing Rock" and "All In the Family". Her work on those films earned her the narrator role as Amy in "Letters to Daniel" the narrative feature which is due to film in June, 2019.

Taura was a generous hearted person who brought complete professionalism to the role of the bitter and angry wife in "Broken" and we plan to work with her again on "Letters to Daniel".

We have done a number of documentaries including, "Something to Believe In:. I worked especially hard on it and happy to say I finally have an NLE editing system so that my films can be all that they can be.

When you are on a budget like I am you have to look for the best software at the best price. I have delved into Davinci Resolve, but my first project on it will be the "Letters to Daniel" Teaser Trailer.

This fall and winter looks to be a most productive time. It was sunny and beautiful today. Having

Something to Believe In

energy on a day like this isn't unusual.

Film production is something I look forward to. In the past I have waited for "the perfect moment". When in reality there is no perfect moment. You start now.

Even when I was sick I was creating. There is no one to grant you permission to go after your dreams. Waiting for the right time will only bring you to the point of having run out of time.

As I mentioned before people are always saying, "You have all the time in the world, that's easy for you to say". I have the same 24 hours in a day you do. No more. No less. (This is repeating exactly what you said in a few chapters ago that is why I added to your first sentence. I would suggest cutting this sentence.) A career writing is fulfilling but it isn't easy or for the feint of heart. Like Nike says, "Just Do It." ®

I have no time for excuses. I know what it's like to have to write into the wee hours of the morning because of schedule constraints. Face it, you're probably going to have to lose a little sleep. Carve out that writing time and hoard it like a squirrel saving for the winter.

When setting about making a movie in the beginning rally your local community or your filmmaking family across the United States or around the world. Write a low budget script. Pick days where everybody can work, and then get down to the nitty gritty.

Learning everyone's rhythms and knowing what gets an actor's best performance out of them takes practice and time. Each time out you learn more about what to do.

For my mental health it's the time between the completion of the script and the time I arrive on set

Amy Leigh McCorkle

to direct that poses the threat to my mental health. The pressures of raising money, building the cast and crew and securing locations weigh heavily on my mind right up until I call action.

I lean heavily on my producer and best friend Missy Goodman. Which in turn gives her a heavy load. For the most part we have learned to work together and our slate is especially full this coming year.

If you are an aspiring director, get a partner who both understands you and your dream and isn't afraid of the challenges you will face along the way. It has taken a while but I am thriving in my dream and am finally ready to swing for the fences.

Chapter 8

In 2013 Missy and I were on the verge of breaking through on the film festival circuit. I was at a convention with four print titles, all of them bestsellers or tracking that way. My books were selling like hotcakes and I was meeting my idols. (I met Adrian Paul but I was totally tongue tied and at a loss as to what to say. I basically said I wrote these, and pushed my books at him.) Being that he was the Highlander I totally fan girled and froze.

Grant Wilson was there too. Meeting him was the highlight of my experience there. Because even though my script was a finalist the win would only mean something when Indie Gathering and AOF backed it with a win and four nominations over two years. It was a finalist at the Terror Film Festival too.

I was hopelessly out of shape and the walk from the convention center to the hotel was brutal. I've since lost over thirty pounds and I'm sure I could conquer it. That con has since gone belly up.

Missy and Pam and me met "Dante" from Clerks. And for my birthday that year Missy took me to see Kevin Smith live and in person. We laughed

our asses off and watched a couple get engaged.

The awards show at Fandom Fest never happened. It was just some lame announcement of their Facebook site. And there would be no trophies to be had. It was a shady affair but the fact my table paid for itself I considered it a win. Along with all the swag handed out.

The writers at this con were never treated with any distinction. Which led to the inception of Imaginarium. To its credit it has outlived Fandom Fest. In 2017 Fandom Fest went belly up in such a spectacular fashion (almost all of their guests cancelled) that they haven't recovered yet.

Imaginarium started out as a writer's affair. And the vibe there was that of a warm and friendly family reunion. Much love was to be had and it was there "Letters to Daniel" had its premiere as a documentary. I have fond memories of that time.

There is a level of anonymity and disrespect you learn to live with when you're working your way to a breakthrough. It's just the reality of the industry.

People love an underdog, but when the underdog starts succeeding the haters will come.

I suppose that's one aspect of the business I could do without. As creators you should be allies. There's to many corporate suits who will be looking to take advantage of you.

Wasting your time being jealous of someone who has executed a win there is really a waste of your time. Energy that could be better spent writing or producing your next film with your allies. It's energy that could be spent towards advancing your recovery. Energy that could be spent advocating for others like you.

Along the way you will meet people who want

Something to Believe In

to take advantage of you. And for people like us its hard to trust because sometimes our illness will cause us to make reckless decisions when our judgment is impaired.

In the entertainment industry maintaining your balance is key to having any success. And since different people have different triggers, it's important that you get to know yours.

The thing is triggers are sneaky little buggers and sometimes they can be hard to pinpoint. For instance packed, closed in spaces trigger me. I get tunnel vision, I can't breathe and often times I burst into tears. Some people want to be left alone at that point, I just want to be held and comforted.

It's embarrassing when it happens in public because to everyone else it's just a good time to be had by all. There is an advantage to not being famous or noteworthy. The chances of your panic attack being broadcast on a global level is very low. But what to do when you're climbing that ladder and people who are supposed to be helping you are really conning you or bringing toxic energy to your healing process.

In my experience the hardest thing to do is to get out of a situation where you're unhappy and your agent is not. I told them I was leaving them and they went into a sort of denial. They dug their claws in deeper and refused to let me go. It took me bringing my dad to the table and forcing their hand. They couldn't leave well enough alone. They had to threaten me on my way out the door. Being rid of them was like being set free from an emotional prison.

Another situation I was in I was simply lied to repeatedly, over the course of a year. By the time I came to terms with it I had frittered away that

valuable time where I could have been promoting my own career. I'm not mad at her. Quite the contrary, I pity her, she's made her bed hard and is an unwell woman.

I managed to rebound from these things and claim victories along the way. I found a line producer and promoter for "Letters to Daniel". (Thanks to Brandon I now know John Spalding of G1NBC) And I found a producer with a capital "P" in Aaron Allen. This weekend I will be filming the teaser trailer for it. Again, I feel a lot riding on this. There are potential funds to be raised and awareness of the film to be increased. Which makes next summer seem doable.

How to manage the stress of all that? Get up. Write. Execute something towards "Letters to Daniel". New script. Edit film. Things that might overwhelm you if you build a routine around them it can sustain you. This Friday I have to make my way to Dunkin Donuts or Krispy Kreme. Either way I have a drive ahead of me.

But you do what you must for your cast and crew.

Feed them well if and give them their IMDb credit. You'll be amazed at the team that comes together.

Managing the energy and stress that comes with pre-production is a high wire act. Eat well, sleep well and take your meds. Those three things are the lynchpin of keeping your sanity and not losing your marbles. Have a caregiver on hand to assist you if at all possible. If you try to do everything by yourself it will only set you up for the bottom to drop out.

You put yourself and the entire production at risk when you try to superman it. And when you're

vulnerable, the con-artists will come, like they did me, and pick your bones clean.

For the most part I am excited by all the creative activity I've managed to put together since getting home from AOF and Indie Gathering. I have a documentary being scored. nine webisodes of a mental health advocacy series in the can, and short script completed. I'm now working on another script, this book and this weekend kicks off the filming of three separate projects.

You strike while the iron is hot because these things have their cool periods. When you're feeling depressed you can look back on your body of work and say this will pass, good times will be here again.

And when you get white hot and the opportunity presents itself you will pop in a big way. Until then keep putting the hammer to the anvil. Your time will come. You just have to keep pushing and keep believing.

Chapter 9

By anyone's measurement, when you look at me and hear my story, I'm a success. Early on in my twenties my career nearly came off the rails thanks to my illness. Now I have a resume to my name that some people would say is impressive.

Define success on your own terms.

When I was sick and at rock bottom, my definition of success was, I want to be well. What did that entail? It was eating right, walking a half marathon, sleeping eight hours a night and managing to write something new every day.

It could be as simple as taking a shower or doing the dishes, or even cooking supper for the household.

How did I reward myself before publishing and festival success? Much the same way I do now. Watching a favorite movie. Going to see the newest Daniel Craig film at the cineplex is always fun.

Which brings me to motivation.

There is no magic formula by which to motivate yourself. Admittedly it's harder than others to feel the urge to pound out a couple of thousand words or so. For me it's about just finding that touchstone which makes the act of writing worth it.

When just the act of getting out of bed is a monumental task, remembering why we write is important. I have all kinds of dreams when it comes to my work: A big time New York contract, mainstream Hollywood success, meeting Daniel Craig and watching Letters to Daniel with him.

I incorporated Daniel Craig into my daily routine by using him as an audience for my blog. That is where I could start, or end, any day off with a conversation about what my life was like with bipolar disorder and how my past experiences had brought me to my present day point.

It was a heady experience. And it has led to my current practice of still writing on the blog and dreaming that my hero is listening to the quibbles of an average girl who needs to advocate for herself and others like her on a daily basis. But it is done comfortably in the anonymity of my home, behind the screen of a computer where he doesn't know anything about my trials and tribulations.

Still, like anyone, I nurse the dream of meeting my hero. It motivates me to sit down and continue my work when I don't want to or when the anxiety seems to be too much. Or the words aren't flowing as easily as others.

So why did I choose Daniel Craig? I honestly don't know. I saw "Casino Royale" and I wanted to craft roles for him to play both in my novels and from screenplays. I've had agent after agent lie to me and say they've gotten my first memoir, Letters to Daniel, to him for him to read.

I dream of him not just knowing of the project but truly getting and understanding what it is and what it has become. I got all this from "Casino Royale", "Cowboys and Aliens", "Skyfall" and "The Girl With the Dragon Tattoo". His work in those films

Something to Believe In

filled my creative tank, allowed me my first tastes of success and to go on an incredible creative journey of my own.

Who wouldn't want to thank someone for that? His work led me out of a dark place in my writing career and allowed me to know the joys of publication. Who wouldn't be grateful for that?

I think if you wrestle with that dark place and you have serious mental illness it is crucial that you find something to believe in. Find what makes you happy and turn it inward. I'm not saying my happiness is dependent upon meeting Daniel Craig.

I have always loved storytelling. Daniel Craig's performances have helped spark my joy in the storytelling process. And it's the act of writing that makes me happy at the core. I'm not saying that meeting him wouldn't have an impact on me, it most certainly would.

But at the same time I have to temper that with, what would happen if he didn't think my work was worthy. That's not something I dwell on often. Just because the chances of meeting him seem so remote I really don't have to worry about it either way.

Daniel Craig doing his best work inspires me to my best work. I know it sounds lame and corny and cheesy but it's the truth. And as long as he continues to put out enjoyable flicks I'm sure my creative engine will have the fuel it needs to burn.

When and if Daniel ever retires from starring in the movies I will have a whole library of Daniel Craig films to inspire me on the gloomiest of days. I'm sorta glad Daniel Craig doesn't know who I am or how I advocate. I'm not sure of what I would say to him.

Seeing that he is an intensely private man, and

I am, well, telling my life story so that people like me can do what I do, I highly doubt I'll be ever given a face-to-face meeting. Still, I dream.

Without dreams, sometimes, there is only darkness. Even when they were in tatters I held on in the most inner recesses of my heart that they could come true. And a big part of that has been "Letters to Daniel". That's what I believed in, my blog, my friendships and Daniel Craig.

In 2011 I broke through. It was a small press, but all the same, I broke through. All three books included characters physically modeled on Daniel Craig. Silly perhaps, but the characters weren't Daniel Craig. They were whatever my imagination projected upon that image and the story would fill that character up. Not knowing who Daniel Craig really is allows me to imagine characters I might not otherwise think up.

Truthfully, Daniel wasn't my only hero. The actor whose advocacy led me to getting into treatment was Maurice Benard. He stars on General Hospital as Sonny Corinthos. He has been open and very brave about his struggles with bipolar disorder. Between wanting to write a role for him and my sister telling me what I needed to request when I returned for the third time to the Center For Health Care Services, I finally got the treatment I needed.

So one might say Maurice got me into treatment and Daniel has kept me there.

That would be an over simplification. I had caregivers pushing me towards treatment and holding me up when I couldn't stand up for myself. Maurice and Daniel gave me back my voice that the bipolar disorder had robbed me of for so many years.

To say now is better than then is an

Something to Believe In

understatement. I still have my rough moments, my bad days, the hard weeks where there seems to be no relief in sight. But no longer am I in constant stormy seas with rogue waves threatening to topple me at the first opportunity.

My touchstone is my writing. My dream hero is actor Daniel Craig. My dream advocate is Maurice Benard. What wouldn't I do to thank them in person? But since I can't, I'll do it here.

Daniel and Maurice. You're like twin guardian angels whose work and advocacy watch over me. Your work gives me the tools to ride out the hard times and capitalize on the good times. Thanks to your "presence" I have succeeded enough that I don't feel the need to prove myself to everyone on the planet.

I confess, at times, it seems pointless to carry on. But then I'll watch a movie of yours Daniel or General Hospital, Maurice and I can feel the creative itch start to drive me forward once more.

I have worked very hard to get where I am. I have worked hard at my recovery and in a way I have survived the hard times due in no small part to both of you to the point where I am now thriving.

Words cannot adequately express all that I am thankful for. I have more good days than I do bad days now and friends who stand by and support me. And even though I never know what the day will bring, I do my best to make it a productive day.

Please when you are struggling to make it through a day find your touchstone and something to believe in. It will be crucial to your survival not just in the industry but in life.

Chapter 10

When you are grappling with serious mental illness quite often in the healing process there will be the lost years. It's just a matter of course. As much as the disease steals from us it seems its last gasp is to steal time from us as well. Time we can't, no matter how hard we try, get back.

It's frustrating when you are trying to move forward when your mind is betraying you at every turn. You desire nothing more than to write but it seems a brick wall stands in your way.

When I'm depressed I pop in "the Insider" and "Gladiator" two films that were pivotal in getting me back at the keyboard. "The Insider" with its cool blue tones and filters was soothing to my jagged nerves. "Gladiator" was rousing and inspiring.

It's important when you're struggling to remember why you love doing this thing we do in the first place. When I am unable to marshal my forces and cope I read a brilliant book, or maybe a magazine.

That's another thing, when you are climbing up be sure to take time to read the industry papers and magazine. Variety and Hollywood Reporter are good places to start. If you're a writer, Writer's

Digest is chock full of information too.

When I was coming up there were several magazines to choose from. Script Magazine, Creative Screenwriting and books like Save the Cat, On Writing, Adventures In the Screen Trade and Which Lie Did I Tell: More Adventures In the Screen Trade.

All are valuable resources.

When your illness seems to have the upper hand and writing is like getting blood from a stone, or doing pre-production work is pushing you to the brink, it's paramount that you listen to your mind and body's signals telling you to rest.

I admit, I'm terrible about this. If I don't produce something at my keyboard everyday I feel not quite right. I'll be sluggish and as if I don't matter. When I write I feel like I have a voice for things that normally would sideline me.

Politics are something I shy away from in mixed company. In today's volatile and highly charged atmosphere filled with intolerance and hatred I prefer to seek out those quiet moments filled with unconditional love. And if you're trying to make it in the entertainment industry it is important to have your touchstones that ground you.

Writing for the sake of writing grounds me in a way nothing else does or can. It's just me and the printed page. I pour out my heart and soul and feel a cathartic release. On a bad day I can figuratively cut my wrist open and bleed out onto the page.

Having people be your touchstones is important. You should always have at least that one trusted friend who will tell you when you're getting too big for your britches. Or as Missy says: "shut-up big head". This is a friendly inside joke, which allows me to remain productive and keeps me from becoming

Something to Believe In

an arrogant asshole.

Grandiosity is something we bipolars have to guard against. Thinking you're the king or queen of the world can get you into trouble. It points to mania and psychosis. Some of us will use drugs and become hypersexual. I didn't experience those things but I did self-medicate with food. As a result I deal with Diabetes and blood sugar issues.

This is where a journal is invaluable. You will note differences in penmanship from when you're stable than when you're manic or depressed. You'll be able see certain changes in your behavior or mood when you look back on it that you can use to monitor yourself in the future.

But where grandiosity is a negative thing, true confidence won by self-care and proper treatment is an invaluable and positive thing that should be nurtured. It can feed your creativity when those demons want to come out and play.

I find when I take things one day at a time, one step at a time or with my writing one chapter at a time, that the confidence is cumulative. When I have a finished manuscript or screenplay I find it to be like a spiritual experience. You are exhausted, but you are on such a high it doesn't matter.

I like to celebrate by going out to a movie, or even a nice dinner with a single glass of champagne. After all, slogging your way through 50,000 or so words demands recognition. You'd think after a book was written the hard part would be over. But no, then comes the editing process and then the marketing. Conventions. Bookstores. Bookmarks, postcards, trinkets designed as tie-ins to your novel. Hotel costs. As an indie, and many times even as a New York Times Bestseller, that responsibility will fall upon you.

Amy Leigh McCorkle

I currently have two books published which focus on bipolar disorder. The Letters to Daniel memoir and the first book in my women's fiction novel Healing Hands Trilogy. The Guardian is ready for an editor. And this book needed to be edited. With these books and after next summer, with my film "Letters to Daniel" I'm going to look into toastmasters so I can conquer the public speaking circuit.

I've done all this as an independent author. I have 21 other titles to my name. I want "Letters to Daniel" to be the bedrock of all of this. I have had wonderful mentors who have nurtured me for the course of my career at different points. They have been magnificent and generous of heart.

I've also survived some con men and women along the way. They cut me to the bone. But as my friend, Mysti Parker, another indie author, said, "Don't they know you get back."

That's something you gotta know going into this business. You're going to get knocked down. People are going to dismiss you. You're going to be disrespected. There are people who will be actively cheering for your downfall. But none of that matters.

You're going to have to put on blinders, keep your eyes fashioned straight ahead and stay in your own lane. Don't worry if someone is selling better than you, because you are selling better than someone else out there. Is it trophies you want? Don't be bitter about the awards you don't win. Rejoice in the ones you do win. There's a convention I sponsor every year. And every last one of the Legacy sponsors have received an award. All of them did but me. I felt a lot better when a) I realized the prize wasn't worthy of my standards and b) I just accepted I would never get the prize.

Something to Believe In

Still, I sponsor the convention so that I can do things that I want while at the convention.

Sadly it used to feel like home. Now it is just an obligation, but that's nothing to be bitter about. They don't see my art as on par with theirs. That's none of my business. I just take the majority of my business where I am respected and loved.

AOF, NOVA, Enginuity, Clifton Film Celebration, LAIFFA, ICFF, ARFF, Script Summit, all of these festivals see me as a worthy, contributing artist and filmmaker. So I enter their competitions and subject my work to their critical eye. Do I always win? No. But I always feel a part of a larger community.

When you ground yourself, it's important to remain humble and grateful and establish friendships with other artists beyond the work. Helping one another out in times of need is a hallmark of a great networking relationship.

Members of that network will reveal themselves as friends sometimes, and you'll be able to open up to some of them. Those people will become some of your greatest cheerleaders in the darkest of hours.

Because there are going to be times when no matter how many tools in the toolkit you throw at your pain, it's just something that will have to run its course. The important thing to remember is that while the pain is intense, it is temporary, and the reward that comes with sticking to your dreams burns hotter, much brighter, than any pain. The process of writing is more cathartic than any illegal narcotic.

Take your meds. See your pdoc and therapist. And lean on your support system. And you will grow stronger and happier. Finding your new normal post diagnosis is so hard but when you do find it grab on

and hold as tightly as you can. Because sooner or later, it all come together for you.

Chapter 11

One of my favorite things about creating is directing from my and Missy's scripts. I recently directed a fundraising trailer for "Letters to Daniel". And, as will happen, we had a crew member not show. Of course, they were well enough to go to work later the same day but when your cast is working for meals and imdb credit you're apt to run into things like that.

Be prepared:
Are the hotel reservations taken care of? Do you have enough food? Do the cast and crew members have directions to the set? Have they safely arrived? Then the morning of the shoot: Is everyone at the meet-up point before you travel to the different locations? Do you have coffee? Tea? Everyone will be looking to you to lead them. Be confident. And recognize, should you hit a snag, that's usually where the magic happens.

Keep the set focused and happy.
And always be prepared.
Being a writer/director/producer is hard for anyone. If you struggle with things like anxiety and depression or bipolar disorder you should always pace yourself to keep from getting burnout.

Everyone should. Burnout can affect even the most average person pursuing a career as a filmmaker. Sleep is paramount. But in indie film sleep is a commodity you don't always have an excess amount of.

Your dietary consumption should be fresh fruits and vegetables, whole grains and lean meats. (Good luck if you master this. I'm lousy at it.) They say garbage in garbage out. And it's very true.

As a writer and director the demand and pressure to be thin is as great as it is on the actress. But there is a certain pressure to maintain the appearance of the perfect professional. And if you battle mental illness on a daily basis the energy you expend putting on that brave face will take its toll.

I'm me.

I've got a polish I wear now to public functions and it serves me well. But I always need to go back to my room and decompress after heavy duty socializing. When it comes to networking I've got to get myself to a certain point mentally so that I can do the work. That's what people mean when they say you've got to get out of your box. The greatest thing in the world is no one has the vision for your future like you do.

I do better in structured events. It's just a fact. If the event isn't structured I have to have a plan of attack. Usually I plan which movies I want to see: My movies and fellow filmmakers I am in awe of. I choose the seminars. I pick if I'll go to the awards dinner(s), if they have one. Finally I make a list of the movers and shakers I want to connect with to get my film made.

I've been traveling the film festival circuit since 2014 with "Letters to Daniel", in some form, in tow. To say it's been a journey of a thousand miles

Something to Believe In

started with a single step would be appropriate. The journey is not over. The journey of recovery never is. But this part finally seems to be coming to fruition. Next summer should be fun, although if you ask Missy, she's not looking forward to it.

When working a festival it's always important to marshal your authentic self. People respond to certain truths and people are just being honest. Some say this is brave, others dangerous, I find it's the only way I can live.

Let me add, being real isn't a pass to be a bitch or dick to people, because it's the only way to be. Ground yourself in the reality that as a writer/director you will always have the power to transport yourself to any fictional world your mind can conjure up. If you find bliss in the writing of your worlds, you have found gold. Because, nothing is impossible.

Well, maybe meeting Daniel Craig seems impossible, but writing and directing my passion project is not impossible. And it's not impossible for you to find what it is in the entertainment industry that makes you happy.

Some say you have to go the college to learn your craft. While college didn't work out for me I managed to network and climb the ladder of success in other ways. I think because I was left to develop my voice alone that it wasn't refined out of me.

That's not to say you shouldn't educate yourself. I've attended workshops, seminars, conventions, film festivals, and this fall I'll be headed to Arkansas for a workshop/mini-seminar for cinematography. An extensive reading list comes with that too. I've collected mentors along the way who have taught me things.

When you step onto your set there's a feeling of

possibility and anticipation that I get when a book is sent off to agents and publishers. All the pieces are in place for a truly beautiful thing to happen.

Choosing the right cast for your film is crucial. Many people use a casting director. I'm afraid I don't have one of those. So I rely on casting sites and Facebook. I don't know if Facebook will change the rules on that sort of thing so until they do I'll take advantage of it.

I don't blindly cast. My actresses and actors have to show they've got what it takes to solidify my vision. Or at least carry the potential for an on point performance.

I love working on set. There's something magical about a group of people working hard to come together and produce an original piece of work that you can show off and be proud of.

Since 2014 I've produced 10 documentaries, 4 music videos, 2 trailers, and 2 short films. I'm proud of my body of work and of how I've improved. I take more chances. This coming weekend I'll film another short and the next another. In January I'll be filming a feature. And June 2019 "Letters to Daniel".

I've also managed to write 6 books in that time. And I've written 30 scripts in that time.

When you are in the throws of producing it is exhilarating. At least the creative side is. The attention to details is, and can be, overwhelming. That's why I'm lucky to have a producer to help me along the way.

I move faster than she likes. And she moves slower than I like. Yet, somehow we've managed to build quite a platform for ourselves. And the magic that happens at the end of all—the complete story, the finished book, a completed script or the finished

film project, makes the whole journey worth it.

The right cast and crew is paramount. They must be willing to go through whatever you ask them to do in order to achieve your vision. So it is important that you operate as a unit and respect the hard work they are putting into your dream.

Make sure you do your homework before you ever step foot on set. Have your shot list and beat sheet in order. Have your angles selected. This valuable information did not come to me through film school but from a fellow filmmaker.

I was told of two fabulous books all writer/directors should have: The Five C's of Cinematography and Save the Cat. A legend, who graciously gave me his number and said I could call him within reason, recommended these books to me. I was honored that he would deem me worthy of his mentorship.

I have managed a crazy schedule over the past few years by simply making sure my butt was in the chair to type the words swirling about in my head. Making sure the cast and crew is fed well is important. To work them without feeding them is not only illegal but plain dickish.

How have I maintained my sanity in this swirl of creative chaos? Simple it is the writing that keeps me anchored. My appointments with the doctor and therapist must be kept. And I must be honest with those around me about my state of mind, even if I'm having a bad moment.

There is a lot of hard work involved with making a movie or writing a book. Some people make it look easy but its not. But if you desire a life in the creative arts, it's possible.

Chapter 12

So you want to make a movie. Take two Motrin and let the feeling pass. Making a movie is an arduous undertaking that tests your creativity, your resources and your very sanity. Even the most balanced of individuals have faltered under the best of conditions. That being said if you're consumed with the passion to create film and have the ability to endure and persevere, then belly up to the bar for a few cautionary tales and the triumphant feeling of arriving at your final cut.

The very first independent movie I worked on was a script Missy and I wrote called "Too Far From Texas". To say the experience was an eye opener is an understatement.

First step: write the script. After an emotional therapy session where I confessed to Missy I felt like the creative part of myself had died, she jumped into action and said, "Let's make a movie." It was the greatest gift Missy could've given me.

We went out and bought a camcorder ala "Blair Witch Chronicles", and in the car on the way home, we brainstormed the script that would become the focus of our summer and early fall.

Next step: casting. We contacted news stations

and newspapers for the casting call. Remember, this was pre-Facebook and we didn't have the money to run an ad in "Backstage". It was also before the proliferation of casting web sites. We had eight people come.

We cast our leads and our supporting cast. We tell our lead actress bring tomboy-like clothes for wardrobe. She brings a pair of shorts that say "juicy" across the ass. During the table read she says, "I don't have to be off book by the shoot date do I?"

In retrospect, these were red flags that Missy and I were heading blindly into a disaster. The next sign was the night before the first day of filming, our supporting actor didn't get the haircut he needed, because he went to a barber on a Sunday only to find it closed.

We filmed on the three hottest days of the year with the a/c off. And from the word go it was chaos.

Me and Missy were very green, and the inmates quickly took control of the asylum. Two of the three cast members didn't know their lines and changed them every take. Ultimately we did reshoots but ended up with an uneditable mess. Very expensive for me and Missy, and it was hard lesson learned.

We even lost power when a hurricane force thunderstorm came roaring through.

Vet your actors. Don't step out on blind faith. And have some idea of whom you will be working with. Divas can wreck a set. You can be a strong leader without being mean. But in independent film people will challenge you. When time comes you will have to let them know who's boss.

On our first film Missy and I lost sight of that. We were the bosses yet the cast and crew ran roughshod over us.

That being said, the steepest learning curve

Something to Believe In

I ever had on a set was "Black Gold: The Trail to Standing Rock". I had never worked with an editor before, and I had two with this one who had never edited a documentary before in their lives.

We were living in the same quarters, and I felt like I was losing control of my movie. Indeed they felt like they were being watched like hawks. My agent at the time was giving advice but right in the middle of the edit, her husband was killed in a car accident.

Everything that could go wrong did go wrong. Yet, at the end of the day, I was left with a powerful documentary that did gangbusters on the film festival circuit. The price I paid (the oil industry and bank's presence were very much felt on this project) was a steep one. I don't talk much to my editors on that film and one of them was a pretty good friend.

But what's it like when it all comes together and it was a happy set. "All In the Family" is an example where the vision came together and it was exceptionally good.

The b-roll footage, pictures, voice over, interviews and music all came together to form a powerful experience. It was me in the editing bay. Clint Gaige as the colorist fine-tuned a few things.

I am most proud of this documentary, because I don't wince at my mistakes so much. Another example of everything coming together is the "Letters to Daniel Teaser Trailer".

The acting, the script, the music, the editing, the directing all came together to make for an effective trailer that demonstrates what kind of film the feature has the potential for becoming.

I'm quite proud of it as I worked incredibly hard on it. I plan on submitting it to a variety of festivals. It will also air on G1NBC.com before episodes of

Recovery Unplugged.

As good as things go, sometimes you'll find people are not always reliable; and they can leave you hanging. That's why it's hard for me to work with people who know me outside the industry. They see working for me as optional even after viewing my body of work.

Sometimes I go against my better judgement and hire them anyway. Maybe it will be good for awhile. But then there'll come the moment where a said individual will bail at the most inopportune time. And when you carry on without them they will turn it around on you.

You don't need people like this.

Cut them out, because they are like a cancer and an impediment to your stability. They will cause you to obsess about the smallest things until they become huge and your irritability becomes anger, which quickly billows out into out of control rage.

And no one really needs that.

When you're on set so many things are happening at once that you must be tuned in to the fact that people who are not cooperating with the team need to be reined in. If someone has at attitude and they're making it difficult move forward, pull them aside and lay down the law.

This is especially true if you're a woman director. People just respond to men in an authoritative manner. It's not that they don't with women, it's just that men have traditionally filled that role.

That being said I have worked with wonderful actors and actresses and terrific crews. Every movie has its hiccups. The name of the game is to find the magic in the gaps and make something truly extraordinary.

Chapter 13

I am fortunate at the moment to be riding a creative wave. My mood is good and I'm relatively stable. I am happy. To say I'm happy is scary. Probably, because this is the happiest I've been all year. The magic of stability comes when I'm writing a novel or memoir. It's where I dig up all the ugliness and the beauty that is the inside of my heart and soul and bleed it onto the pages of whatever I'm working on.

I'm balancing the book, a script, two more movies on the horizon and further ahead a movie in January. Then I do the dream movie in June, "Letters to Daniel". I have my support in place, because generally speaking, starting a whole bunch of projects is a sure sign of mania. The writing is easy to handle.

Granted, when I put my butt in the chair I often face the paralyzing anxiety that comes with the blank page. Directors have a whole army, so if something goes wrong they have someone they can blame.

Except on my sets. There's usually me, and, if I'm lucky, one other crew member there to do the duties of a crew. My casts are always so vulnerable,

and they trust me. I accept their willingness to trust, and I in turn trust them. It's a high wire balancing act, but worth it.

Writing is therapeutic for me. It tires my brain and makes me feel like I scrubbed my insides. Even though I love the scriptwriting process, it often leaves me feeling like I could do more.

So in order to get started I live my writing life by three rules:

1. *You gotta reject rejection.*

2. *Seat of the pants to the seat of the chair.*

3. *Don't get it right, get it written.*

These three rules plus doing NaNoWriMo (National Novel Writers Month), where my goal was 1667 words day. I trained myself into a pretty disciplined writing machine, where all I wanted to do was write. And write I did.

There are various schools of thought on what to write. Some say write a marketable book. But what does that really mean? I'm here to tell you, if your heart ain't in it it's not going to be sellable. You have to move people emotionally, and if you're not moved, then your readers aren't going to be moved.

Do you dream of bestsellers and fancy book tours paid for by New York. Here are some stark facts. Only the top 5% of bestselling authors get the marketing money. Every other author has to do it for themselves.

Small press is really a good training ground, they provide you with covers, editors, and if your publisher has it together, there's a group with

marketing ideas for you to implement.

Going indie means you keep all the profits, but you also foot the entire bill.

Everyone is going to decide what works best for them. I dream of New York but I really don't write the length they want. My sweet spot is 40-60K. I've written a few 70K novels. But if I'm honest they weren't my best work. So I'm not small press much anymore. I have pretty much gone full-blown indie as a writer.

As a filmmaker I make really cheap movies. So I'm indie by circumstance. But with "Letters to Daniel" I'm praying for that big breakthrough. I'm putting all the time and effort that I compress into fast, run and gun shoots and taking my time with it.

It's hard though, because my personality is fast. I talk fast. I write fast. I film fast. I'm not saying to do it my way, because sometimes it's harder this way. I've had people say I wish I could write as fast as you. Well it comes with a pretty steep price tag. When I'm not creating it's the worst.

When it's rainy and overcast for an extended period of time I suffer emotionally. I'm irritable, and when I'm irritable everyone around me knows it, and it makes for a miserable household. Sometimes it will just make me sleep. Which I don't like either. Sleeping the day away feels like wasted time. Then the years I spent in recovery to get to where I can manage my illness feel like wasted years.

It's hard to look back sometimes without becoming depressed. It's why I push so hard now to be at my absolute best. I create for creating's sake. I want to be paid a salary for it, but the reality is getting that big break takes a lot of stepping out on faith, and then putting action behind it.

There are people who are sick of hearing about "Letters to Daniel". They think it is a gimmick. Who tells their life story to a favorite actor they don't even know? What's Daniel Craig got that makes him a compelling stand in for an audience? He's safe. I don't know him. At all. He hasn't the foggiest idea I even exist. But because of that he won't judge me for my truth telling. I can't hurt his feelings by expressing anger over something that happened years ago. And I can't make him sad for the same reason.

In short, he won't judge me. Everyone else I know has a stake in it. How will it be received? Will my friends look at me the same way. What I found in writing my memoirs as a blog was that people were for the most supportive.

The morning I created the blog at 4am and my dad was up getting ready for work, I told him what I was creating it to tell my life story and advised him not to go looking. He said "he was okay, because he was starting a blog too called, All the Lies Amy Tells." I busted out laughing. He knew what I was doing and was supportive. He also knew there might be some unflattering stories and him. Just as many of the stories were unflattering about me.

When you have bipolar disorder you're not always the nicest to those who are caring for you. Your best efforts are sometimes not good enough to quell a situation. That's when a journal would come in very handy. You can blow off steam in a memoir.

The reason it took me so long to write my memoirs about having bipolar disorder was because I needed to heal and get some perspective. When you're in the throws of it it's hard to see the other side.

Something to Believe In

It's being in a pitch black room and not being able to find the light switch. It's absolutely miserable in there. You feel isolated and alone. Like no one gives a damn about you. Writing the Letters to Daniel blog was a magical experience. Everyday that I wrote I got that much better.

It was an amazing feeling getting up every morning and putting down my experiences. I didn't alone because I had my audience of one who wasn't going to judge. What I found was there were people reading my blog and commenting on it. Telling me this was their story too. Or that they loved someone with bipolar disorder or that knew someone with it. It didn't take me long to realize I was advocating for me and my message was reaching other people.

It happened by accident and I have expanded my resume to include a trilogy where the heroine had bipolar disorder, a stand-alone dystopian novel that targets stigma in the church, and now this book. I have three documentaries about serious mental illness. I strive to do more. I hope to go on the speaking circuit soon. But that's another book. And another story. All this came from a desire to write and to write truthfully.

Chapter 14

As I creep up on the eve of another shoot I am reminded of why this is my least favorite part of production. Contacting actors can be a bit like herding cats. They can be a bit flaky and remain out of touch for long periods of time. For someone organizing the last minute details it can be frustrating and anxiety inducing.

That being said I love to work with actors. Watching them shine in their element is part of the magic of the movies. I couldn't possibly do what they do. And the best actors make it look so effortless.

Standing in front of a camera, even if it's just for an interview, can be nerve wracking for me. That's why I look for the best team to put around me.

This Saturday I will be working with two actors (male) with whom I have never worked before. I worry about a lot things leading up to it. Will they respect me? Can I rise to the occasion? Will things go smoothly? Will the end product measure up to my desires as a director?

Watching myself for obsessive thoughts connected with the anxiety is another thing. I'm still

hanging on to a stunt someone who was a no show pulled, and now they've got me on radio silence. Given my propensity for making mountains out of molehills, I wonder if I'm just imagining things or if they really are sulking, because I chose my production over them.

You simply cannot wait around indefinitely for people to keep their word. They either will or they won't, and you've got to learn to deal with it. (Honestly so do I.)

But looking out at this Saturday, I have people coming in from Cleveland, Knoxville and eastern Kentucky. I can't focus on last week. I must concentrate on the present in order to keep from being paralyzed.

On the other hand this Saturday promises to be a grand adventure. I'm filming in a restaurant. And it's a new genre for me. My past excursions have been romantic drama heavy on social issues. This is simply a comedy. The lead character is an egomaniacal agent who is a chauvinist of the highest order. His co-star plays it straight as an actor a little past his prime who wants no part of the agent's scheme.

The lead, of course, has all the best lines. He's outrageous and totally over the top.

Missy and I wrote the script in 2006 and we have always wanted to film it. So, finally, we are. I'll be soloing it on set with one other person behind the scenes there to feed the actors lines lest they lose their way.

Missy and I sat down and made the shot list the other day. There's really only four shots to get. The question is, can my cast navigate it cleanly. At this point there is no point in worrying. They either are or aren't off book and I will work with what raw

materials I have.

I've worked with the actress playing the waitress before. She has zero attitude. She's just so grateful for having the opportunity she shows up prepared. The other two I've never worked with before, and both have given off signals they may not know their lines on Saturday. It wouldn't be the first time I had it happen but it is never ideal. Because, it ends up taking longer to get the take. And that costs money.

Still, a good attitude goes a long way. If set morale is good all the way around, then problems can be weathered on set. It's just that they have a tendency to show up in the editing bay. Where I hear a rendition of "line" repeatedly.

But my advice when staring down the barrel of a production deadline is to take a deep breath and allow yourself to breathe. Set up small goals towards the big goal. And give yourself plenty of time to execute them. Write them down on a sheet of paper. No less than three things a day. I find when I write stuff down I am infinitely more productive.

It allows me to focus my thoughts and target one thing at a time. Wrangling my thoughts is a bit like wrangling actors. Sometimes it's like herding cats. Each though interesting and shining has a mind all of its own and will act of its own volition.

But with a list I can conquer things once thought impossible. Certain things for me, mundane routine things such as brushing my teeth and taking a shower must go on the list. I once spoke to another friend with bipolar disorder and they expressed the same difficulty with these things. It's something the world at large wouldn't and doesn't understand. But I'm here to tell you put it on the list and work it into your routine. Over time things will become

easier to navigate.

I get nerves all the time. Driving. When dealing with unpleasant people and situations. I have a bit of the people pleaser in me. And I have a long temper when I'm stable for the most part. But if something is sacred to me (my work) and you shit on it, then here comes the rage.

None of my friends outside of Missy and my close family members have ever seen me fly into it. When faced with adversity my talent has been to adapt and endure and be aware of my triggers. I'm not perfect at it but I've learned to ride the waves of bipolar disorder over the last nineteen years.

In the process I've had the pleasure of achieving some of my life long dreams. I've dreamed of being a published author and a film director. It may not look like what I thought it would but I've accomplished things most people only dream of.

My journey recovery has been long and still continues to this day. Most of my success has come as a kind of second act. At 35 my first book was contracted. I'm 43 now with 5 books waiting to be published and a sixth to add on top that when this book is finished.

Since 2011 I have had 23 books published. Some better than others, but I'm proud of them all. Some are written under my pen name, Kate Lynd. And the others under my given name, Amy Leigh McCorkle. We wrote our first competitive screenplay in 2012 and started hitting the boards with it in 2013. To say I am blessed beyond measure would be an understatement.

Is the struggle daily with mental illness? Yes, you never know what the new day brings with bipolar disorder. That can make stepping out into the chaotic world of film production scary.

Something to Believe In

For instance, I have anxiety when I drive. And I have to drive some place I've never been to Saturday morning, in the dark. I'll be leading my actors and script supervisor there and they're from out of town. That's a lot of stress for me.

But I put too much into it to just "give-up". I've been doing things one day at a time and tomorrow I will go to the Super 8 Motel and check in early for the coming arrivals. Sometimes, often times, it's a fight to accomplish just one thing on the list.

However, what I have learned over the years is even on the bad days when nothing is accomplished, just getting out of bed is amazeballs and should be applauded. If you're feeling overwhelmed on the day or days of filming make a list the night before and just take it a step at a time. Because believe it not the magic will take care of itself.

Chapter 15

It's hard to see what the end product will look like when you begin at FADE IN. I mean, as a writer of a novel I never know what the end is going to look like. I get glimpses of it along the way. Maybe a shootout on a bridge. Or a massive action sequence to set the ball rolling. A love story only hinted at the beginning will bloom into an epic romance turning your heart inside out and wringing unexpected emotion from you that will snowball into your biggest project.

I have many experiences writing the next story. They've begun piling up. But it always amazes me when someone reads my stuff and tells me how much they loved it. That they've got a new book boyfriend, or that my work changed them in some fundamental way.

Recently someone messaged me on Facebook and asked what writing classes I took. In elementary school I was part of the success program. You had a notebook for math, science, language arts and one especially for English composition. As you might guess that was my favorite one.

There were three other people in my fourth grade class who also all loved to write. Christopher

Thacker, Joe Leonard and Andrew Underwood, who also was very good at drawing. The three of us would always take the writing prompt in such different directions. It was as if we were all competing to see who had the most entertaining story. The real winners were our classmates when we read them out loud.

After that year I was no longer in the Success program and the three boys were sent to their home schools.

Years later I would open the newspaper and I would find that one of them had perished along with two of their friends when their car stalled on a train track. And still another would battle alcohol addiction. I don't know what became of the third. He seemed like a gentle spirit at nine years of age.

Life has a way of grabbing you up by the throat, slamming you hard against the ground and daring you to get back up again. I spent a great of time on the ground in early adulthood.

It always felt too hard to muster up the strength to get back on my feet and dust myself off. But eventually I always did. Then a magical thing happened. It wasn't that it didn't hurt getting knocked down anymore.

But now the stinging didn't last so long. And getting up became second nature. The mountaintops of my dreams didn't seem so impossible to scale. If I kept my head down and persevered one step at a time I would get there.

Something to keep in my head: always be grateful. This means when you're winning, when you're losing, and especially when you're stable. When you're sick be grateful for what sacrifices your caregivers make for you.

Gratitude I find to be more a way of life than

things you tick off a list. Oh to be sure it starts with the list and grows from there. What is so beautiful about gratitude is that it comes from learning to love yourself when sometimes the odds are so much against.

Granted when I am depressed it's hard to be grateful for anything. That's when the list comes in handy. Just making a daily habit out of what makes you grateful to be alive, can lead to stability when used with your other tools.

Today I woke-up at 5:30am and rushed to get ready for the shoot. Got dressed, took my medicine. Did a coffee run for everybody. Then we all piled into one of the actor's cars and caravanned over to Coach's Grill.

I could focus on the horrendous ambient noise on the location. But instead I chose to focus on my former brother-in-law's generosity and willingness to let us use his restaurant to film "Back On Top".

He didn't question the subject matter and he didn't demand script approval. All were wonderful things. I'll have to keep that in mind as I move forward with filming my feature in January.

Always be grateful to have locations. It has to be one of the strangest aspects of putting a film together. A lot of times you can fashion a script to shoot at one single location with a lot of creativity.

I have re-purposed my mom and dad's house countless times as settings for interviews in a documentary or for a narrative short film, or even a trailer. I have to say this is always my greatest challenge. Pinning down public locations to use is hard. People are often suspect in my area. They are afraid of the intrusion camera, cast and crew brings.

As I look for locations beyond these shorts and

to "Letters to Daniel" which demands some serious doctor's office space, I worry. I have a therapist's office at my disposal. But there are three therapy scenes and a daycare scene.

It takes so much planning. Today started at 5am. I've managed to film and get a rough cut of "Back On Top" done, and call and book the location for our auditions. And I'm writing this. Like I said, there's a lot to be said for to-do lists. Mine simply was to have a successful shoot. And I feel like I did.

Now we start all over with next Saturday's shoot: "The Therapist." for which, the actor playing the husband has dropped out. I'm debating whether to recast or to just rewrite the last scene altogether and write the husband out of the movie.

Those are decisions best made on a well-rested head. Of which mine is not. One thing you should always do when you're paying in IMDb credits is to give them free coffee and meals. So often times in indie film you don't have the cash to pay them in the truest sense. You must do all in your power to provide them with a positive experience. Show gratitude at every turn.

That being said, there will be people, who let you down. There are going to be people who betray your trust in this business. And it will burn like fire. The trick is not to let it embitter you. Bitterness is a one-way street to everything you have worked against.

Perhaps you're just starting out and fresh in your recovery. Your knees are shaky and your arms feel like spaghetti. Yet as you sit down to a notebook, a journal or a manuscript the journey you are about to embark upon beckons to you.

There will be storms, there will be uphill climbs and there will be people who actively work against

you. Know this, I once had an individual threaten that she would do all in her power to keep "Letters to Daniel" from flourishing. It scared me. This was in 2014.

"Letters to Daniel" has been and continues to be a popular blog. It has been a zero budget proof concept award winning documentary. It has been a bestselling memoir. It hit the top ten in four countries and the top 100 in two others. And it has been an award winning narrative screenplay. Currently it is a trailer making its festival rounds. Come June the screenplay will be filmed.

The moral of the story? The only person who can stop you is you. So commit yourself to getting better, getting braver, dreaming bigger and embrace life and your new normal. Whatever that might be. Because I'm here to tell you, when success comes to you later in life, there's nothing sweeter than what that tastes like.

Chapter 16

One thing I really like about the film industry is going to see the movies. Not just independent films, although the way the industry defines independent isn't fair. You know those serious films with an A list star in them, I refuse to call them independents. Muti-million dollar budgets define studio pictures. Let's see someone do what I do and call it a studio job. Less than a thousand dollars, no name talented actors and actresses, and stolen shots over a day or two.

Granted I've gotten more sophisticated since the beginning. My films are color graded now and I have a composer who works on the sound as well. I'm getting there bit by bit step by step. It's hard to make a movie. You better love the process, because if you don't love the stress, it will bury you.

I once tried to do all the pre-production at once on what would have been "Letters to Daniel". No one was helping me, and I was without a therapist. By the time we were nine days out from filming I was hanging on by my fingernails. Then the other producers pulled out nine days before filming sending me spiraling into a depression so deep that I was left wide open to be taken advantage of by

some less than above board people.

During this time I watched Daniel Craig movies of course. But one of my favorite movies is "Gladiator". The heroic character played by Russell Crowe has the core values of strength and honor. Those are qualities that seem to be sorely lacking in people.

I don't mean physical strength is important. I'm talking about psychological and emotional strength. If you have a mood disorder you have the capacity to endure hellish conditions your mind unleashes on you. It's like being under attack by your own brain.

During these times your brain will lie to you. It will tell you that you are weak and ugly and that no one loves you, and that you're all alone. Your brain will be present giving convincing arguments, and if you are vulnerable to these attacks it's especially important that you reach out to your support network during these times. Reaching out is moving from a position of vulnerability to one of strength.

It is a powerful tool to have. Even if you just have that one friend who you contract with when feeling suicidal, it's important to know when you choose to live, you choose to embrace the belief in brighter, better days. When gratitude is hard to come by that friend who has chosen to be your caregiver is there for you to lean on. You don't have to pretend you're feeling good. Because, sometimes the reality is, you just don't feel good.

Sometimes you just can't get out of bed. You want to. But if you can't, call that friend. Maybe she or he can lead you to get up and go into the kitchen for that cup of coffee. If you ask, maybe you can head to your favorite park and enjoy a walk.

Better yet, check the showtimes at your local

theater and go see a comedy with your friend. Then afterwards go to your favorite place to eat and get a tasty treat.

When people have the flu we take care of them. Bring them soup, ginger ale, sometimes grilled cheese sandwiches. But when mental illness strikes, society has a way of stepping back in fear of what they don't know and don't understand. They ostracize instead of warmly embracing you and bringing you a casserole.

When I'm having a really rotten day I throw everything I can at it. Therapy. Writing. The walk. Music is balm. Music is a motivator. Music gives me the inspiration to keep going when I don't want to keep going anymore.

An author once said writing is not all inspiration and craft. And that very rarely do you feel like you're in the flow. That it's a job and often times feels like a slog.

I disagree.

It's not a job. It's a calling. Yes, it is hard work. Yes, it demands long hours. It demands your sweat, your blood your tears. It demands all your heart and all your soul. Yes it's about flow. It's about hitting that sweet spot and riding the wave. And craft, yes it's about craft.

My process took years to form. Some are faster learners than others. If you don't find the joy in the process of writing go find a 9 to 5 job where you can punch a clock and get paid for your work every two weeks.

I'm not trying to be mean but all too often I hear, I can't, if I just had more time. As I have said earlier, I have the same twenty-fours in a day that everyone does. Some would argue I have the luxury of time. But that, in and of itself, has its

drawbacks.

People assume because you don't have a destination to drive to you don't work as hard as everyone else. They don't know putting pen to paper, though glorious, is just as mentally and emotionally taxing as any other job.

I have twenty-four hours in a day and the goal is to get one chapter on a book and one scene on a script done in a day.

Yet people won't recognize it. Even some of your supporters will see you as non-career oriented. They will just assume you're available to make life easier for them. The trick is always finding a balance.

Sit them down. Try to be honest with them with how you're feeling. Use "I" statements to take ownership of those feelings. If you are an adult and are living with your parents there will have to be a certain amount of give and take. My parents are well into their 60's and yet one is still a full time lawyer and the other is a part time teacher.

I am on disability for my bipolar disorder. I don't receive much in the way of benefits but I value my insurance. It enables me to receive much needed medicines, which I would not otherwise be able to afford.

So it's inspiration, craft, process and the all-important self-care. The self-care is so important. Writing when in the throes of psychosis will get you nowhere pretty fast.

Have a treatment plan. I've been living with bipolar disorder for so long sometimes I forget I have it. And then a bad day will come along and wallop me on the head and let me know that I do indeed have this illness, and I need to take better care of myself.

Something to Believe In

It doesn't help I have diabetes, which can also affect my mood. I tend to fall down on the physical fitness side of things. I mean I know after a lifetime of success and failures what I need to be doing dietary wise but exercise is boring. That is unless I go to Iroquois Park and relish the sanctuary that I find there. I mean I just have to get out of the car and walk under the canopy of trees there and I am immediately transported to a stress free environment.

I am no longer able to get to that park as often as I'd like, so I have turned to what has been a godsend. I love participation medals and I love distance racing. And Yes.Fit.com they have themed races of all kinds.

I've done All Roads Lead to Rome, which had a cool gladiator helmet, sword, and shield medal with the Roman Coliseum embossed upon it. As you log in your miles on your computer you get the digital experience of participating in the race. Things, such as famous landmarks, villages, and historical trivia await. And you get the joy of doing it at your own pace and competing only against yourself.

I walked tonight for the first time in over 6 months. It felt good and I know my health both physically and emotionally will benefit from the 20 minute walk up and down my hallway tonight. Usually when I exercise I sleep better too.

That is all important self-care.

So when you sit down to create remember to bring your whole self to the table. You'll be surprised by the results.

Chapter 17

On days like today where I've spent it doing things other than writing, I tend to feel wrung out and out of sorts. Writing brings about a certain peace of mind that I don't get doing anything else. Not to say today was unproductive.

Missy and I started going through the actor submissions for "Letters to Daniel" today and I emailed the first round that we are interested in. I voted.

But I've been agitated and angry today. When I get woken up and I don't want to be woken up it's to everyone's disadvantage. It means the night before I didn't get my sleep out of my system.

However, I have walked a mile and am prepared to feel somewhat better. I'm doing the Beauty and the Beast race. So it was mile 2 today. It's inch by inch. Little by little. It's a 26.7 mile virtual race and it's my third one.

That self-care I was talking about in the previous chapter, it can't be emphasized enough.

I hated getting up from the keyboard but still it has infused me with the energy to do what I need to do.

So now, I face a third Saturday in a row where

I will be filming. Because of unexpected setbacks I will be filming with a different actress than initially anticipated. I don't know if she's any good but I'm game if she is. The other actress I'm excited to work with again. Both actors actually dropped out at the last minute. They had their reasons. All it tells me is that they can't be depended on, and I need to move on.

Still, this Saturday should fun. We have an awesome location to use that's secured for the shoot. The hotel is provided for the actresses. And food will be provided on Saturday after we film. I might get a dozen donuts from the local bakery to feed them, along with coffee from McDonald's. An IMDb credit will have to suffice. Meanwhile I'll be handing Valyo, my composer, his fourth project in a month to score.

My biggest piece of advice in putting a film together is take your time. I can usually run at a racehorse pace. But if you notice, for "Letters to Daniel" I'm taking my time. Bit by bit. The cast is unwieldy. There are 47 roles to be cast. And we have to be sure they aren't going to flake out at the last minute.

We started the process of going through submissions today. We got through quite a few of them but there's a lot more to go.

The biggest stress I have right now is, will we have our original picks for Amy and Missy. We initially casted the film in 2015. But it's been hard to get it together. So finally, we are putting it together a piece at a time.

Missy gives me a little to do at a time. It would be easy to get overwhelmed with pre-production. And having bipolar disorder, having her there to walk me through it, has been a godsend. The magic

of Healing Hands Entertainment is we balance each other out.

Her friendship has been the glue that at times holds me together and keeps me steady. Do you have someone like that in your life? Someone who can help you actualize the big visions in your creative mind; someone who thinks creatively and complements your efforts.

Missy doesn't even want to produce films, yet, she does it because she knows I need to direct and create. "Letters to Daniel" will be her directorial debut. I'm so proud of her. She worries about me and what I can tolerate. Most of my films shoot over the course of a day or two.

"Letters to Daniel" promises to be our largest shoot to date: in money, in manpower, and in length. The script is 93 pages long. And we know going in we've only got seven days to do it in. This is a massive amount of pages in only seven days. People tell me only shoot five a day or at most eight. We're looking at thirteen and change a day. People on set will have to be prepared for long days and brutal nights.

We pray we get good weather to shoot in. It's a primarily indoor script but it has enough exterior shots to make it interesting. The decision has been made that the film will primarily be shot in Kentucky with two locations being provided in Ohio.

Our vocal talent is currently compiling all the voice over tracks. I can't wait to hear them. In a way I've been living in a Letters to Daniel world since 2013. I wonder how I will feel when the film is completed and distributed.

I have big hopes for "Letters to Daniel". They are the kind I dreamed about as a teenager when every March I would watch the Academy Awards. Is

it wrong to wish for something so fervently?

It's a dangerous tightrope to walk. To get one's hopes that high is dancing awfully close to my bipolar's triggers. Keeping long hours. Pounding caffeine. Eating poorly. All these things can and do wreak havoc on my nervous system.

And when my anxiety is up it's hard to do my job.

So what can you do when you can't help but dream big dreams and run yourself ragged? Build in time to rest.

Rest is so crucial to recovery and maintaining your sanity. If you figure out how to do this let me know. I find joy in working creatively. And I find when I'm not I'm often spinning my wheels.

Missy says I'm a workaholic. But that doesn't mean I don't enjoy going to see a play or a film. I like to gather with friends and celebrate the holidays. Certain family is good to be around.

People often say their significant other is their closest ally. I find romantic relationships troublesome. You have the delicate matter of breaking it to them you have a serious mental illness and that particular part of you makes day to day experiences difficult to plan.

You might be happy one moment and in despair in the next. It takes a special person to love someone with bipolar disorder, because most relationships take work to work. When it is romantic you also have to differentiate between hypomania and the first flush of romantic feelings.

It's like that working on a movie. You start with the script. Where you first fall in love. Then move to looking for the money and pre-production. There's nothing joyous about. It's just pure, unadulterated hard work. Then you get to the set. Where, if you've

Something to Believe In

got your partner, it can be a beautiful experience.

Onto editing where your hard work and vision come together.

All my films have taught me something about myself. How much criticism I can take. When it's constructive I always grow from it.

And that's what any relationship is like. When you're making your film it feels as if you have a purpose.

Do I wish or long for a romantic relationship? I admit it would be nice. But to be honest, it is scary for me to think about. The making of a film always nets a final product. It's something to show and be proud of. A relationship is a potential heartache. To be fair, I had my share of heartache. For now I'll just stick to writing and making movies.

Epilogue

I've wracked my brain and I think I've come to the end. When it comes to a journey of recovery it's important to remember that there are many facets in maintaining an equilibrium. Much like when you're tackling a creative project.

The most important thing in your journey to professional success is the ability to persevere. To endure. To always be taking one step at a time forward, reaching up with one hand and down with the other to help pull someone up.

Take your meds. Keep your doctor and therapist appointments. Be honest with those around you with how you're feeling. Exercise and try to eat right. Get enough sleep. Show gratitude for the good things in your life. Implement self-care tactics.

Go to the movies. Watch television. Read books.

And by all means keep creating and never, never quit.

About the Author

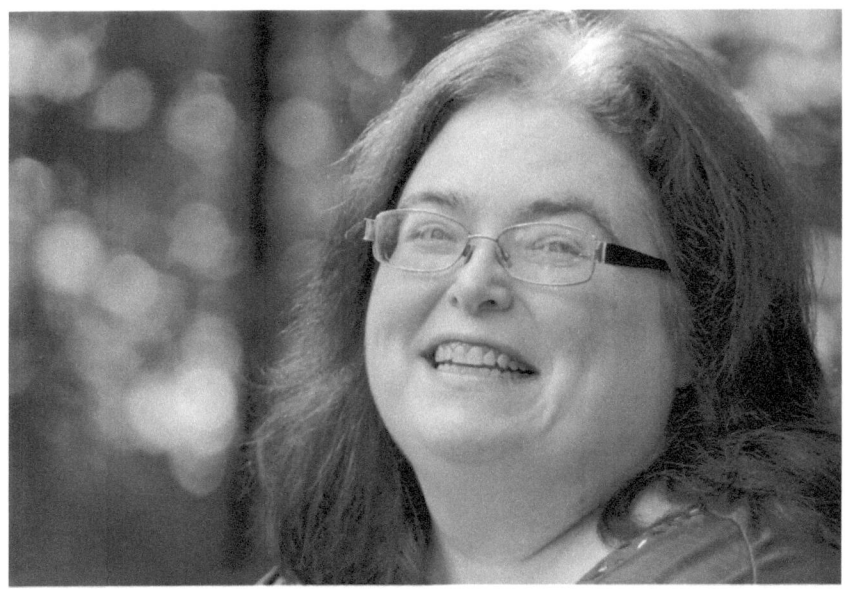

Amy Leigh McCorkle resides in Shepherdsville, Kentucky with her orange tabby Luke. She loves coffee, writing, and filmmaking. She spends her free time watching the Golden Girls and Fraiser. And hopes one day to meet her hero Daniel Craig. Until she is content to create at will and advocate for herself and those like her.

www.ingramcontent.com/pod-product-compliance
Lightning Source LLC
Chambersburg PA
CBHW022017170526
45157CB00003B/1263